NO BEATING ABOUT THE BUSH

Val Oldfield
AS TOLD BY ASHLEY MALLETT

To: Diane Bird

Enjoy

Val. Oldfield
22·2·13

**10 years living with the dust, dingoes
and extraordinary characters
of the Birdsville Track**

First published 2013
Text copyright © Ashley Mallett 2013
Photograph copyright © Val Oldfield 2013

All rights reserved. No part of this book may be reproduced, stored in a retrieval system, or transmitted in any form or by any means electronic, mechanical or otherwise, without the prior written permission from the author.

Every effort has been made to ensure this book is free from error or omissions. However, the author and the editor shall not accept responsibility for injury, loss or damage occasioned to any person acting or refraining from action as a result of material in this book whether or not such injury, loss or damage is an any way due to any negligent act, omission, breach of duty, or default on the part of the author, or editor or their respective employees or agents.

NO BEATING AROUND THE BUSH
By Val Oldfield (as told by Ashley Mallett)

ISBN: 978-0-646-59349-4

Designed by ApplePi Design 0414 847 789
Printed in Australia by Graphic Print Group
Adelaide, South Australia

Tribute

No Beating about The Bush is told in tribute to the women of the Outback, who have worked tirelessly in the harshest environment on earth, dedicating their lives to the wellbeing, comfort and love of their families.

Dedication

This story is dedicated to the memory of my daughter,
Susan Joy Oldfield.

(1961-2009)

Foreword

In 2008 (four years ago) I decided it was time for me to write the memoirs of my life in the 1960's at Mungeranie Station on the Birdsville Track. I had no idea how difficult and time consuming writing this book would be! Looking back, I think of it as a long and winding road with many pot holes along the way, and so difficult that at times I wanted to abandon the whole idea.

The support and encouragement of my family and friends has been amazing, and now that I have finally reached my destination (the completion of the book), the sense of achievement over-rides all of the difficult times.

It is a record for everyone, especially my family, to enjoy the account of the funny, sad and happy times that I experienced whilst living in the outback.

Please enjoy and share with me, *'No Beating About The Bush'*.

Val Oldfield
November 2012

Acknowledgements

I take this opportunity to give my special thanks to the following people who gave of their memories, time and care to help in the creation of *No Beating about The Bush*: my close life-long friends, Barbara Sheppard and Joan Williams, who helped jog many memories and gave me wise counsel; my husband Denis, who has patiently supported and encouraged me to see this book through to fruition; Joan and Jim Dunn; Alan Thompson; John Letts; Tom and Valma Kruse – sadly now deceased; Peter and Vera Jeffs; Alison Redden; Phillip Oldfield; my cousin Rex Way who reproduced the excellent photographs.

My very special thanks for the great cartoons that are so relevant to my story drawn so brilliantly by George Aldridge.

There are many others who have unwittingly been a part of this book's creation, namely those who have played parts in my life and who feature within the text. Perhaps most significant of these have been my children, including Ken, Martin and my daughter Suzie, whose memory never leaves me.

Thanks to Bill 'Swampy' Marsh for permission to use a small extract from his book on the Royal Flying Doctor Service,

Great Flying Doctor Stories, (ABC Books, Sydney, 2007 PP 67-68). Information was gleaned from Winifred Stegar's* book, Always Bells, Life with Ali, (Angus & Roberston, London-Sydney, 1969) which helped paint a word picture of life in the bush long ago.

My appreciation goes to Celia Painter and my friends who helped me edit this book. Thank you to the SA Writers' Centre for recommending Ashley Mallett to tell my story. Thanks also to Phil Gibson from ApplePi Design for his help in designing and printing my book.

No Beating about the Bush has been a long, but interesting process. In a way, it has been therapeutic, requiring me to reflect on my past and organise my recollections. In doing so, I have been able to provide a lasting record of my family's 10 years on the Birdsville Track and a written dedication to the memory of my darling daughter, Suzie Oldfield, who passed away in 2009.

Val Oldfield 2012

Contents

1	Once Bitten	1
2	Growing Up	11
3	Eric Oldfield	35
4	Outback Terror	45
5	Mungeranie: 'Big Ugly Face'	57
6	The Muster	75
7	The Good Life	83
8	Animal Farm	91
9	Rita	107
10	Marree	117
11	Thunder Down Under	133
12	Swallowing Poison	147
13	Drought and Flooding Rain	155
14	Farewell Mungeranie	169
15	Life after the Outback	185
16	My Darling Suzie	197

Once bitten...

Susan burst through the door and yelled, "Miss Raelene has been bitten by a snake!" I remember it as clearly as if it was yesterday. My darling six-year-old was like any other little girl of her age. She was full of energy and blessed with imagination and an enquiring mind, but she also had a tendency to embellish things. Sometimes, even in the best of circumstances, she feared the sky might fall in. It was mid-afternoon. I watched Susan shrug her shoulders. My little girl, miffed at my indifference, then defiantly tossed her head back as if to say, "mum doesn't care, so why should I".

I had made the near fatal mistake of dismissing Susan's concerns. Miss Raelene, frightened out of her wits and obviously in shock, burst into the kitchen. She had indeed been bitten by a snake and the governess's experience would soon be confirmed by her deteriorating condition.

The snakes about our property at Mungeranie Station homestead, a 6,070 square kilometre cattle property about 850 kilometres north of Adelaide in South Australia and in the middle of the Birdsville Track (the Track), were mostly deadly. Among the slithering reptiles were angry browns, death adders

– all potentially killers – and the less venomous black snakes. One had to be wary of these and also spiders at any time of day on the Track.

Miss Raelene was holding up her left hand, frantically pointing to her left thumb. "The snake bit me right here," she yelled, indicating the tiny, thin-skinned part behind her thumbnail. She shook uncontrollably and we were both scared out of our wits.

Living in the middle of 'nowhere', in one of the driest parts of the driest states, of the driest continent on earth, we could not simply grab the phone and call the local doctor when there was a medical emergency. Nor could we ring an ambulance and expect help within the hour. We were so remote. In an emergency, we relied heavily upon the Royal Flying Doctor Service (RFDS) medical chest. Each station homestead had one and medicines were clearly numbered and labelled. For direction in their use and other medical help, we would contact the RFDS by wireless – our call sign was 8 double Peter Mungeranie (8PP) – and speak with a doctor. Wherever possible, the patient would sit beside the person speaking on the wireless. An explanation of the type and extent of the injury would be given to the doctor who needed to know: where the patient was feeling pain; whether it was sharp, dull, throbbing, constant, or irregular; and its duration. Based on the information and responses to questions, the doctor would assess the situation. In life-threatening circumstances, the RFDS would send a small aircraft, sometimes carrying a doctor, to treat and often airlift the patient to a hospital. People who lived on the 'Track' had to be tough as old boots to put up with such difficulties for any length of time.

Upon the RFDS doctor's advice, I once gave a young jackaroo a penicillin injection. Luckily, during Red Cross First Aid and Home Nursing courses, which I had undertaken in Adelaide, I had been taught to put the needle into a spot I had marked on a patient's bottom with a biro. After a while, I was pretty confident. I would draw a little cross and plunge the needle in the exact spot. On this occasion, I looked at the young man and said, "Right, drop your pants." He was so shocked he did as he was told, "Okay, turn around and bend over," I said. I swabbed the spot, ready to mark with biro and with that the young man took off around the bedroom, thinking he had already been stabbed with the injection. So much for the tough Outback man!

To survive in the Outback, you did this and many other things that seem extraordinary to many city folk. The medical chest had to be kept up to date and medicines regularly replenished. It was very much a lifeline, vital to Outback survival. For the Flying Doctor to call at your homestead was something of a last resort – very much a last-ditch effort to save someone's life. The governess was terrified. She held her left thumb by her right hand and moaned.

In those days, the idea was to bleed the snakebite area. During the drama that evening and night, even the noise from the men drinking in an adjoining room did not distract me. I knew the governess was in real trouble. I rummaged through the medical chest, scattering medicines, needles and bandages all over the floor, frantically searching for a scalpel. My thoughts were centred on Miss Raelene's dire situation. As in all medical emergencies in the Outback, it was vital to think clearly and

act swiftly. "Found it, thank God," I heard myself say aloud, almost as gleefully as if I had just plucked a 'nugget' from the medical chest. The scalpel's blade had a keen cutting edge. All the good medical kits in those days carried these razor-sharp blades as the 'manual' maintained that snakebite had to be bled and the poison sucked out. In the 1960's, we didn't know much about washing the wound, wrapping the snakebite area firmly with bandages, or applying a tourniquet. We would see it in all the old Western movies; bleed the wound and suck out the poison. I had heard all the rough jokes about snakebites and how a man, bitten on the penis, asked his drover mate what was about to happen to him. The mate, realising the only thing was to suck the poison out, looked at him square in the eye and said, "I'm sorry, mate . . . but you are going to die."

The area between Miss Raelene's thumbnail and knuckle bone, where she was bitten, was so thin-skinned that I could not bleed it sufficiently. I was afraid the snake venom would travel deeper into her bloodstream.

I decided to call my husband, Eric, who had our portable 8SKV wireless in his Toyota, as he would know the best course of action. He was kilometres away on a cattle muster but within radio range. Eric responded and confirmed my thoughts that RFDS help was needed if there was any hope of saving the governess.

As I tried to get in touch with the doctor, the poor girl's condition seemed to be getting worse. Her distress was obvious. Occasionally, she became a little hysterical amid the bouts of sweating and nausea. It was getting darker outside and at that time during my early married life, in the early 1960's, the Royal

Flying Doctor Service base closed at 5pm. To contact the base after that time, I needed to use a special two-pronged whistle. We would turn on the wireless and blow into the short and then the long side of the whistle to create an emergency sound. The system had been introduced to provide some form of communication, on a 24-hour basis, between the RFDS base and the Outback cattle stations. Unfortunately, this primitive communication method rarely worked but when it did, the RFDS doctor base would automatically swing into action.

I tried for some time in vain to make contact with the RFDS using the emergency whistle. Meanwhile, the health of the young governess further deteriorated, shivering and sweating profusely. Her pain was obvious. She appeared to be falling into semi-consciousness. Her prospects were frightening.

Gratefully, my whistle signal attempts at contacting the RFDS base were picked up by a stockman in Oodnadatta. He contacted me over the wireless and said, "Don't worry, Val. I'll ring the RFDS base and let them know you are in trouble."

It seemed like ages, but it was probably only a short time before a doctor's voice could be heard on the radio and we were able to discuss our governess' situation. I had limited medical knowledge, but knew instinctively that she would not make it through the night without expert medical help. Her state was declining rapidly. All the while, two Shell Company representatives, Alan Thompson and Denis Haig, were blissfully unconcerned, sitting at the kitchen table drinking beer. I know that Alan recently recalled that he did not believe there was much they could do, so they sat enjoying cold beer, listening to the RFDS doctor talking over the wireless. They

could not see Miss Raelene in the next room, but the door was open and they could hear her moans. I remember the doctor asking, "What type of snake bit the girl?" I replied, "I don't know." There was a brief silence, and then he declared mournfully, "Ah, well she probably won't last another hour. If it's a brown snake she may not have that long to go."

There were many venomous snakes at Mungeranie Station, but who knew which species had bitten Miss Raelene? The way she was deteriorating, I knew the snake was poisonous. As my cousin, Joan Dunn (nee Barlett), who lived with her husband on the 6500 square kilometre Kalamurina Station, 58 kilometres from the Track, would often say, "The only good snake is a dead one." I find it extraordinary that even the deadliest snakes in Australia are protected.

On contact with the RFDS doctor, Alan Thompson thought he sounded English and 'like all Poms', presumed anyone bitten by a snake that was beyond an hour's medical assistance would surely die. He ran through a whole list of percentages. If it's this type of snake she has got 30 per cent chance of survival, if this one, 40 per cent and so on.

The doctor finally agreed to fly out to the homestead. He gave me an estimated time of arrival. Meanwhile, the girl screamed and the Shell reps continued to drink in the kitchen. Just the fact that she was still alive seemed to be a cause for them to celebrate. I was not in any mood to be jovial at the time.

The plane arrived earlier than expected and flew straight over the homestead because night had descended and we had not illuminated the airstrip. It was just a strip of rough, red

gibbers but looked a treat during daylight, with bright white tyres along its borders but at night the tyres melded in with the dark landscape. Night landings in the Outback were highly dangerous, especially as we did not have a proper lighting system at our little runway. The Shell reps, Eric and I lit up the homestead and tore out of the house. We jumped on and into vehicles to rush to the strip so we could light the way. I was on the back of a motor bike, my apron flapping in the wind as we high-tailed it. Air rushed past my face and my eyes scanned the skies. This was exciting, almost exhilarating, for nothing much seemed to ever happen in the outback. Usually, we would wake to the mournful drawl of the crows… aaah, aaah, aaah and day after day, year after year, most days would continue in the same dismal tone and pace. This was different. We felt very much alive and on-the-go, albeit at Miss Raelene's expense.

As the pilot aborted any chance of landing and made a low sweep of the area in preparation to return, we hurriedly lit up the runway with bonfires on either side of the roughly hewn red gibber landing strip. We had a motorbike, a station vehicle and Alan Thompson's four wheel drive, all with their lights on full beam, positioned along the side of the airstrip, to provide extra guidance for the plane's landing.

Regardless of the bonfire and vehicle lights, we knew that the night landing was still very dangerous – the pilot would need to make a calculated guess as to the distance between the aircraft wheels and the ground just before touchdown. Talk about flying by the seat of his pants.

The landing was a rough one, but the plane and pilot

came through unscathed and the doctor was rushed to the homestead to attend to the sick girl. Alan Thompson had been right. The doctor was an English-born medical graduate, Dr Michael Green. Despite my hesitation – generally fainting at the sight of blood – the doctor insisted I assist him. Dr Green quickly prepared tubes and inserted a needle into the girl's arm. He was administering snake anti-venene. Because the snake venom was in Miss Raelene's blood stream, her blood pressure must have been sky-high and the tubes kept blowing out. There was blood everywhere – splattered over the furniture and walls – and Miss Raelene was most distressed. Strangely, she was concerned about the fuss she believed her tears and screams were making, and apologised for doing so. All I could do was to hold her hand and reassure her that she could scream and cry as much as she needed to and that I was there for her and she would be okay. She was terrified and inconsolable, despite my continued assurances that she would be all right.

Then there was silence. Miss Raelene seemed to calm and the doctor wiped his brow of sweat. I asked him if I could wash away the blood from Miss Raelene before they left for Port Augusta Hospital. He turned to me and shook his head. With the best Oxford accent he whispered to me, "We haven't the time. I don't think she'll make it through the night." The governess was placed onto a stretcher and carefully lifted inside the aircraft, the doctor by her side, as it took off again.

We all feared for the girl, but thankfully, the doctor was wrong. Miss Raelene was in a coma for a couple of days. While it was touch and go for some time, happily our governess

pulled through. In fact, the girl made a full recovery. As for the type of snake that had bitten her, there was always a bit of a mystery about it. It seems it was on a bed in the men's quarters where Miss Raelene had been preparing the room for a new jackaroo.

Growing Up

Apparently, Miss Raelene thought the snake was a leather belt and when she thrust out her hand forward to pick it up, the snake lashed out and bit her.

A few weeks later, we had guests stay at the homestead to take part in a gymkhana (horse and rider events). We needed beds and mattresses from the workmen's quarters brought to the main house for them. I shall never forget it. As Eric brought the mattress from the men's quarters, a small snake, which I think was a death adder, fell out of the bedding onto the concrete floor of the porch where we sat. The snake must have found the mattress a warm safe haven over the winter.

As for Miss Raelene, it was very much a classic case of 'once bitten twice shy'. Her time at Mungeranie Station homestead was over.

A few months later (December, 1967), Australian Prime Minister Harold Holt disappeared during a swim at Portsea Beach. Right under the gaze of all his minders and security staff, Mr Holt dived into the sea, never to be seen again. The news was so dramatic that it reached us relatively quickly, but not within the few hours that city folk experienced. Our

isolation was always 'enemy number one' and it reinforced our vulnerability in a situation where any one of the families might fall victim to a major accident or snakebite.

Years later Alan Thompson re-visited Mungeranie Station. He asked Eric what had happened to the girl who was bitten by a snake. Of that conversation, he recently recalled that Eric did not exactly show him his compassionate side, saying that it did not matter that she never came back to Mungeranie because, 'she was a bloody dud anyway!' I never agreed with that view.

Even into the 1960's, the Track was at best, a tough place for a woman. There were, of course, the obvious dangers with the ever-present potential for snakebite and accidents. However, the worst of it all was the isolation and the loneliness in places that were so desolate you might as well have been on the dark side of the moon. Isolation could also lead to depression, as it eventually did for Eric and me, driving an invisible wedge between us and ruining what began as a marriage made in heaven. Within a few short years, living an increasingly lonely and dangerous existence on the Track, the honeymoon was well and truly over, despite many fun times and happy memories.

Blissfully unaware of the global conflict of the arm's race that had all but 'consumed' the interests of mankind, I came into the world in the Adelaide seaside suburb of Semaphore Park on September 5, 1939. A 'war baby', I was third child to my proud parents, Eva and Walter Burnard and my name Valma always seemed to be shortened to Val. My father once ran a farm in the Mallee, but later, Wally, as everyone called him, became a racehorse owner and trainer.

Just down the road lived Mrs Day, whose home we

eventually bought. She had dozens of cockatoos as pets. I cannot forget the inevitable flapping of the birds inside the house and the ever-present birds scurrying under quandong trees and tall daisy bushes where dishes of water were placed.

Dad loved the spaciousness and our large allotment to shelter, water, feed and exercise his beloved horses. The rambling old weatherboard house, which groaned and creaked at the slightest wind, was at 172 Military Road and stood on 1.2 hectares of land. Daisy bushes, tall pines and quandong trees were prolific in the garden. My favourite tree to climb was a huge old Norfolk Island pine. We had a much larger run of land when Dad later leased an extra 2.4 hectares to accommodate his growing number of quality racehorses.

Many children, mainly cousins, stayed during the summer holidays as they loved the beach and our rambling old house with its huge garden. Among our regular visitors was Eric Rowley and his older brother Ron. Eric was about my age and the boys had lost their Mother when they were both very young. Their father, Leo, was a great friend of the family. My wonderfully warm-hearted Mother showed Eric and Ron the affection they dearly needed. I thought of Eric as my brother and we shared a very close friendship. They were happy, carefree days for Eric. He remembers riding with Ron on their bikes from Kilkenny, about nine kilometres from where they lived, to our house, most weekends of the summer. The beach, just over the road from our family home, was the place to go. Eric got to know me over a number of years. He says he was devastated when I married and went to the Outback to live. Eric married in 1965 and when his wife, Pamela, died a few

years ago, Eric's sister-in-law, Elizabeth, encouraged me to get in touch with him and attend Pamela's funeral. It was a very sad and bitter-sweet occasion. It was terrible that the wife of a loved childhood friend had died but it was equally joyous to see that old friend after 40 years. He did not recognise me. Now, we are back to being good friends. I was recently very flattered to learn that he said I had been a tower of strength to him upon losing his soul mate. We always keep in touch and the conversation often goes back to our childhood and those happy summer days we spent together by the seaside.

It seems from the moment I began to walk, I was put on one of Dad's horses and so began a daily routine of helping him exercise them in the sand hills and along the seemingly endless stretch of beach just across the road from our house. The sand hills came right to the edge of the bitumen road and trailed back to the water's edge. It was the perfect environment for the horses.

While I was keen to help my Dad, I never developed a real love of being around horses or riding them. Dad tried to teach me to respect horses and to see the beauty in them, but unfortunately, although I managed to respect them, I never really grew to love them. Once on the beach, I fell off my horse and suffered a bloodied nose. Within seconds of the fall, riders from the Colin Hayes stable turned up. They looked down at me as though I was an alien from outer space. Feeling very embarrassed, I jumped up and remounted my horse and rode off. From then on, I was always wary of horses. Dad never gave me any sympathy and whenever I had a fall from a horse he always encouraged me to get straight back on.

World renowned jockey, John Letts, or Johnny as I often call him, was apprenticed to Jack Canavan, a horse trainer who lived a short distance away. Every morning, he used to work the trainer's horses through the sand hills and along Semaphore Beach. Dad and I would work our horses along the beach, north past Escourt House at Tennyson and south to Henley Beach. Johnny would fly past on his horse from Caravan's stables, always with a big wave and the cheery greeting, "Good morning Val. Good morning Mr Burnard".

Johnny used to also ride track work for Dad. On one occasion at the races, the rider of Dad's horse, El Fairis, failed to arrive on course and Johnny volunteered to ride him at the hurdle race at Morphettville. It was John's first and last hurdle race as, upon seeing a couple of horses topple in front of him at the second hurdle, he ploughed into them. Years later, another well-known jockey, Wayne Crouch said to him, "Hey, Johnny, you know what the colours were that day you fell in the hurdle race?" "Yeah, they were Wally's colours – pink and grey," said Johnny. "Yes, Johnny Letts, pink and grey – same colours as a galah!" came the retort.

Johnny thought the world of my Dad as a trainer and a friend. He acknowledged the care Dad gave his horses. Many a time, he got hold of a horse that other trainers reckoned wasn't any good but with his care and love of the animal, these so-called hacks won many races. Among the horses Johnny rode in races for Dad were Samboru, which won the Goodwood Handicap (also won by Australia's greatest sprinters, Black Caviar in 2012). Sambarou later broke his leg and had to be put down. It broke my Dad's heart as it was one

of his favourite horses. Among other winners were, Log Cabin and El Fairis.

In 1972, Johnny won his first Melbourne Cup on Piping Lane and in 1980 he again won the Cup, this time on the Colin Hayes' trained Beldale Ball. Johnny would say it was amazing what winning a Melbourne Cup could do. Before 1972, Johnny had never raced outside Australia. The Cup win opened many doors. Soon he was racing in South Africa, Asia, America and Canada. As Johnny says, "win any major race and your sporting world changes forever."

During the 1988 Oakbank Carnival, Channel Nine producer Des Flavel and Johnny discussed the idea of interviewing the winning jockey of the Great Eastern Steeple immediately after the horse went past the winning post. To do so, the interviewer would need to be armed with a microphone and talk with the jockey as they rode along together. They tried it at Oakbank with Johnny dressing like an English gentleman on the hunt and brilliantly conducting a post-race interview on his beloved Banjo, a former stock and show horse. The practice was adopted for the Melbourne Cup in 1993 when Irish raider Vintage Cup was the winner. Johnny, on Banjo, was a huge hit with both the crowd and television viewers and the interviewing practice, with the dream team of Johnny and Banjo, has since become a tradition.

Banjo's spot at Flemington on race days is familiar with punters because Banjo not only smells the roses, he eats them. Along the front of his stall and the little area where Banjo waits patiently for every interview with Johnny, Flemington's famous roses are bereft of blooms. Banjo's popularity among

racing fans both delights and amazes Johnny. He says people who attend on race days just want to pat Banjo and Banjo loves the attention. He knows he is important.

Johnny got a big thrill out of the impact of the Melbourne Cup victory, as it does with any jockey who wins it but Johnny maintains that some of his most treasured memories are working with my Dad because he genuinely cared for his horses. Despite being a huge fan of Lester Piggott, referring to him as the greatest jockey of his time in the sport, Johnny says it was Dad's care and love for his animals that helped him become a world famous jockey.

My earliest memory of riding was the day Dad gave me Mr Chips, a horse from the local pony club. If I looked like falling off, the horse would lean over to stop me from falling out of the saddle. Dad often laughed about this. Down on the beach, I would throw the reins over Mr Chips' head and walk along collecting shells with the horse following me like a little dog. He really was a lovely old horse. Dad's calm presence helped, although I don't think I ever really got over my fear of horses.

Later, Dad said I could have a retired steeplechaser called Gun Hero. He said, "If you can ride him, you can have him." Gun Hero wasn't going to let a mere slip of a little girl control him. The instant I got on him, he took off, bolting across the main road, through the sand hills and along the beach, parallel to the surf, his back legs kicking and his mane tossing violently. I struggled to hold the reins and was still screaming when Gun Hero bolted into the front yard. Dad was there, waiting to catch the reins and end my misery. Next day Dad said, "Val, you can't ride him, so I'm putting him on the market." Dad sold

Gun Hero that very day. Horses were always around – a bit like having a bike. I rode the horses only to help Dad and I guess, to please him. My real love was the beach.

My Mother, Eva Emily Burnard (nee Bartlett) was calm and loving. When she smiled her face 'lit up' like a Christmas tree and when she played the piano her skill "lit up" the family home.

My older brother, Bob, contracted diphtheria and died at the age of 10, a year before I was born. My Mother also contracted the disease, as did my other brother, Ray. Mum was so ill with diphtheria that she was unable to attend Bob's funeral. I can't imagine how difficult it would be for a Mother to not be able to attend her own child's funeral. Poor Dad must have also suffered. It was a terrible time for the whole family. Whenever I look through old family photographs, I detect the sadness in my Mother. She had a lovely smile, but family photographs must have brought back the tragic memory of Bob, her first born. Mum probably never recovered from that terrible sadness.

My Mother's mood was never helped by Dad who seemed to attract female attention. He was a handsome man and women seemed to gravitate towards him. Mum's tolerance of these women was amazing. She certainly knew how to control my father, giving him a certain amount of freedom but if any relationship looked as if it might develop to more than friendship, the message was given that all was not well and the particular woman simply disappeared from their lives. I so admired my Mother for her cleverness. I have no doubt that my Father loved her dearly and would have done anything, given her anything, to keep her happy.

Our next door neighbour, Barbara Sheppard, used to take a great interest in our family. She said my brother Bob was a great friend who was the spitting image of Dad. Barbara says she always remembers the day the ambulance came for him. Bob had contracted pneumonia as a result of diphtheria. Pneumonia all those years ago was a virtual death sentence. Barbara spoke to Bob as he was being taken to the ambulance, "You'll be home soon, Bob." But he never did come home. Barbara recalls that Bob's death really hit my Mother hard. She used to cheer herself and us up with her beautiful piano playing.

The brother I did know well was Ray, born in 1933. While he was six years older than me, we were inseparable in the summer months. At that time of the year, we virtually 'lived' at the beach. It could not have been long after the clock struck six and we would both jump out of bed, don our bathers and climbed out of Ray's bedroom window to run across Military Road, over the sand hills and down to the seashore. We swam in the sea and played on the beach, dragging seaweed through the shallows, often catching dozens of little fish, which we later learned were small flathead.

All the children in the area seemed to congregate at the beach, playing in the sand dunes or on the water's edge to their heart's content. I never really remember learning to swim, other than my brother and his mates taking me out in water well over my head. It was literally a matter of sink or swim. I swam for my life until my feet touched the sand in the shallows.

Every now and then during the Spring, big trucks would arrive over the road and sand would be dug out and carted away

for the manufacture of glass, or so we were told. When the sand was first taken, there would be high 'cliffs' created in the sand hills and we would jump from the edge of the 'cliff', or as the bank began to erode, slide down the face of it. At the beginning of summer, we had initiation ceremonies. The toughest 'trial', was to lie in the sun on a large, flat boulder until we were red raw from sunburn. At home, Mum would douse us with methylated spirits, which had an immediate cooling effect. If the sunburnt skin began to peel, the punishment was to again lie out on the boulder in the hottest part of the next day. If the raw skin still did not turn brown, we would lie out there again. Only hunger and fatigue told us it was time to leave the beach. It was always late in the day, having trudged reluctantly back from the water's edge.

Towards evening on a hot summer's day, Mum and Dad usually had a swim and we often went down to the beach with them. Mum would, on our arrival back at the house, put the hose down the front of our bathers, showering us with the cold tap water, washing the sand and the salt from our bodies. After being hosed down, we would go into the laundry, take off our bathers, dry ourselves and put on our pyjamas, ready for the evening meal. As you might have guessed, it was taboo for us children to go straight from the beach into the bathroom.

After a day at the beach we were always dead tired, able to summon just enough energy to wash, dress and have tea before jumping into bed. The quicker we got to bed and went to sleep, the faster the new day arrived – another day at the beach. Overnight, Mother Nature set to work. With a sweep of her magic wand she transformed the sand dunes and the

following day the dunes always looked different. There were new shapes in the sand hills – a new world for our new day. When the tide went out, it revealed its treasures in the form of armies of sand crabs, ingeniously hiding beneath a small pool of water, the only clue to their whereabouts were tiny air bubbles. We looked for the bubbles and grabbed a stick, prising a crab free. An array of seashells was always on display, but only the most unusual found their way into our possession, to be proudly displayed in our bedrooms. Unfortunately, we were oblivious to the fact that they often had a living creature in them, until the putrid smell wafted into the kitchen.

I always reckoned that if someone ran off with me when I was a child, they would soon bring me back. With an older brother and mates his own age, I did whatever they did. I climbed trees and helped dig out brown snakes from the sand hills. Whenever we actually disturbed a brown snake, we would toss the shovel aside, race home and excitedly encourage dad to come and finish the job. Dad was the best snake killer I had known, not that I had known many!

Holiday-makers at Fort Glanville didn't escape our mischief. They were the 'enemy'. Most of the people were from Broken Hill who stayed in tents at Fort Glanville, which was close to where we lived. Their toilet 'block' was an open-air affair, hidden behind four posts and wheat-bag walls. We had chooks and ducks. The ducks, especially, would skip across the road and lay their eggs under the box thorn bushes in the sandhills. Many of the eggs went rotten and as I was the smallest, I became the one to retrieve them from under the box thorn bushes. These rotten eggs were perfect for our cause. Our gang used to target

NO BEATING ABOUT THE BUSH

someone who went to the 'open air' toilet. We would sneak up to the wall and toss the eggs over the wheat bags. It stank to high heaven and anyone who happened to be in the toilet got out fast. We would stand, laughing, as we surveyed the scene. There was our 'victim,' rotten egg in his hair and oozing down his face, clutching his pants that hung precariously between his bottom and his knees, frantically trying to run away. Other 'victims' included the odd nude sunbather. A mortar-type barrage of rotten eggs, all thrown in unison, attacked these characters. They rarely returned to their secluded spot in the sand hills. Rotten duck eggs proved the very best ammunition. We never tired of this sort of fun and after one of our brilliantly co-ordinated rotten duck egg attacks, we would be off like the wind. Those summer days were wonderful.

The 1950's were carefree days. People left the front doors of their homes open and their car keys in the ignition of their vehicles. Rarely was a home invaded or a car stolen. People made their own fun at that time. There were few entertainment outlets other than the movies, so the children had to be creative and use their imagination. We grew up fast and became street-wise a great deal quicker than most young people today, many of whom would rather sit down and play computer games than be playing outside with their friends in the fresh air.

My parents knew all about making their own fun. In winter, the family often gathered around the piano and sang songs. Mum was the pianist of the family and Dad's strong voice tended to drown everyone else out, but he was never a match for our little fox terrier, Patch. When Dad began to sing, Patch howled. As Patch howled louder, Dad's voice became louder.

Winter nights meant eating chunks of toasted bread and drinking cups of cocoa in front of the open fire. Dad bought loaves of bread, cut slices and toasted them, using a long piece of wire to hold the bread close to the coals. When toasted, he smothered the bread in butter and it tasted, oh so good.

One day I came home late after basketball training. I had been watching my weight during training and my brother Ray teased me about not being able to have any toast or cocoa. I calmly picked up his mug of cocoa and poured it over his head. I was used to being around boys and gave as good as I got. I guess I was a bit of a tomboy. There were very few girls in the neighbourhood, so I hung about with the boys. The experience toughened me and was probably good preparation for what trials – physical and mental – were ahead of me.

Other than fish and chip shops, there were few outlets serving cooked food and hardly any restaurants. Most Australian homes in the 1950's ate the traditional evening meal of meat and three vegetables at a laminated table, surrounded by chrome chairs. We ate that traditional fare and sat at a large wooden table with decent solid chairs, not those of the chrome kind which were frowned upon by many.

Foreigners were as scarce as hen's teeth in the late 1950's. Our first encounter with an Italian man was at the local picture theatre at Semaphore. Our whole family went along and as we were settling into our seats, Mum whispered to my father, "Wally, I think we should go home. The man sitting alongside me has a gold tooth and very bad breath!" This was the Burnard family's first experience with garlic. Later, with the flood of more immigrants in Australia, we would soon become a nation

that was no longer under the conditioned national heel of 'meat and three veg'. We also learnt that squid was good to eat, not just something to bait your fishing hook with. Maybe the Burnards were the quintessential 1950's family. Our parents worked hard, the family ate three balanced meals a day and we attended Sunday school.

I don't think we were particularly religious people but going to church on a Sunday seemed the thing to do. Maybe, it was 'conditioning'. Unlike other families, Dad didn't attend church as his horses needed to be exercised early every morning. Dad was always there – rain, hail, shine. While I loved riding, getting up in the dark on a frosty morning was not something I enjoyed. When it was bitterly cold, I wanted to stay curled up in my warm bed, but Dad's idea of a friendly wake-up call was to come into my room, put a cold hand under the blankets, grab my big toe and pull me out of bed. There was a time when I tried to dissuade him, even sleeping in the nude, but Dad did not worry at all. Usually, the sun was barely up when we took the horses across the road to the sand hills. It was an exhilarating ride down the steep slope of the sand hills on to the flat stretch of beach. The horses loved the sea air and the freedom to run flat out. They would toss their manes and in no time a leisurely trot became a gallop at full tilt. I had to contend with the very basic of saddles, a jockey pad, which took some getting used to and I had to hang on for dear life. My role fitted nicely with Dad because I could help him exercise the horses before I went to school. That continued right through my high school years and early working life, before I married and went to live with Eric at Mungeranie on the Track.

The 1950's were years of the Cold War, fear of all-out atomic warfare, the expectation of the Melbourne Olympic Games and the emergence of Bill Haley and the Comets. Elvis Presley, the greatest rock star of all, then emerged and Neville Shute's film, *On the Beach,* stunned us all with its story of a nuclear holocaust shattering the innocence of an era. It is said that legendary Hollywood actress Ava Gardner, who had the lead role in the film, was asked how she liked Melbourne, to which she replied, "Melbourne? What better place to make a film about the end of the world?"

While Australia was a free democratic society, it was far from free in some areas. The most sought-after books in the world, D.H. Lawrence's *Lady Chatterley's Lover* and James Joyce's *Ulysses* were banned Down Under. I think all the youngsters at the time wanted to take a look at *Lady Chatterley's Lover,* even Frank Hardy's *Power without Glory* was banned due to the threat of libel. Although we were a free society, it was conservative and chaste. Bans on wearing bikinis on Bondi Beach and bans on certain types of books that were, in any way, sexually explicit, had Australians using the word 'wowser'. There were thousands of wowsers about in the 1950's.

In the 1950's, the credo for women was to serve the needs of the man. The perfect image of a woman was that of a wife and mother, who never seemed dour or depressed when her man came home. His day, by definition (probably by an all-male group), was always more stressful than her day. She therefore listened to her husband, nodded her head at appropriate times, soothed him with a gentle touch of her hand and let him unwind.

There was the FJ Holden, the Astor radio and in 1956 we had the Golden Girl, Dawn Fraser, heroine of the Melbourne Olympic Games. Before that, Queen Elizabeth II visited Australia. More than 50 years on, Her Majesty is still our monarch.

There were no supermarkets in the 1950's. It was still the era of the corner shop. We went there for a few items at a time. Children could buy an ice block, an ice cream in a cone, or a chocolate frog for 'a song', although it was rare for us to do so. My special treat was to accompany mum to the butcher shop, where she bought her meat for the week and the butcher would give me a piece of fritz. As I became a teenager, there was always the milk bar, where real milk shakes were on sale. As the years wore on, the milk bar held greater fascination. It was a place for a girl to meet a boy. Money seemed to go further, a pound could buy a variety of goods for children in Semaphore Park in the 1950's.

Summer was always the best time of year. Schooling was another thing altogether. I didn't like it one little bit; having to attend school every day took away my freedom. I can still smell that horrid, dank odour of the lunch box and I did not like eating those sandwiches. After consulting the school doctor, my teacher was forever sending home hand written notes to my mother saying Valma is lacking this or that. I remember hiding my cooked beans under the ledge of the dining room table at my grandparents' house at Mile End. I was very wiry but slight in build. I really didn't like food, particularly vegetables. No wonder I was a very thin and scrawny little girl.

My formal education began at Ethelton Primary School. I stayed there until grade five, when I switched to Grange Primary

School, followed by my secondary education at Woodville High School. I eventually got to like school, mixing with people and learning a wide range of things. Science was probably my best subject. One year, much to the amazement of my teacher, I topped the class in science and domestic science. Maybe I had a scientific bent because years later, when living in the middle of nowhere in the Outback, I began collecting an extraordinary array of stones, petrified wood and remnants of meteors and comets which, over millions of years, had scattered their terrestrial treasures on our desolate landscape.

Having passed my Intermediate Certificate I began to think about what I should do for a job. I was 15 and had studied a commercial course at school. Earning money in the 1950's was not the motivating factor it probably is for today's youth because a young girl was not expected to stay in the workforce forever. Peer pressure tended to dominate. My Father told me I was reasonably pretty and was likely to marry at a young age. "Therefore," he said, "there's no need for you to extend your education beyond the Intermediate Certificate." Young girls worked for a few years, then found their perfect match, got married, settled down and had children. Their dream was to own their own home. But finding Mr Right was not all that easy. Social contact for teenagers to meet the opposite sex was limited to meeting people at work or at a dance. Even when the opportunity arose for a young couple to 'go further' than a kiss and a cuddle, young ladies were reluctant to do so, for condoms were not always reliable and there was no contraceptive pill available. Society was none too kind towards girls who fell pregnant.

I had plenty of boyfriends, but rarely did anything ever progress from the odd stolen kiss in the back of a car during the short break at a local dance. I would go to the dances with a few girlfriends. One parent would drive us there and another would come to pick us up. We used to love going out the back of the dance hall and judge how good the boys were at kissing. Any boy who dared open his mouth, or 'tried' anything, was banned from our group.

When I was 17 years of age, I found a job I loved as an usherette at the Ozone Theatre on Semaphore Road. I could dress up in my pink and white candy striped blouse, heavy brocade skirt and seven centimetre high-heeled shoes and somehow I managed to run up and down the aisles putting people into their seats. My life revolved around exercising dad's horses first thing before breakfast, then clerical work at the Adelaide Stevedoring Company, theatre usherette work three nights a week at the Ozone, and attending all manner of debutant balls, dinners and cabarets. Life was exciting and carefree.

The manager of the Adelaide Stevedoring Company was a former British Merchant Navy Captain William Atkinson Clingly who had a distinctive English accent. He loved puffing on his pipe and was a racehorse enthusiast. He knew my dad through their horseracing connection. Dad was a trainer and Captain Clingly was a racehorse fan and sometimes racehorse owner. In fact, Captain Clingly and Dad formed a syndicate at one stage, owning Samboru, a chestnut sprinter by Makapura out of Magic Wonder. Samboru won a number of quality races in Melbourne and Adelaide, excelling over the 1000-1200m distances. Captain Clingly's son, Mick, played football and

cricket for South Australia. Mick Clingly was the last man to kick a goal in the South Australian National Football League with a place kick. A great sporting character, Mick would shove the racing form guide in his football sock and check the results as they put the numbers up on the scoreboard at the footy. He always knew when Samborou was racing and how he fared.

While I had plenty of casual boyfriends, there was no one really special in my life. At the age of 12, I was invited to a party to celebrate the engagement of my cousin, Joan Bartlett, to Jim Dunn. Jim was indirectly related to the one of the pioneering families of the Track – the Oldfields. Jim was owner-occupier of Kalamurina Station, an isolated cattle property on the edge of the Simpson Desert. Many of the Oldfield's attended the party, including a good- looking 18-year-old called Eric Oldfield. I was a girl in pigtails, who quickly became infatuated with Eric, whose family owned and managed 6070 square kilometre Cowarie Station, about 50 kilometres from the Track, midway between Marree and Birdsville. Later, I attended Joan and Jim's wedding. Again, the good- looking Eric Oldfield was there. Wow, Eric was so handsome. He had dark hair, the healthy, tanned skin of an outdoor man on the move and a beautiful smile. During the celebrations, I wanted to accompany my grown- up cousins to another function, but my strict and protective parents were not in a mood to compromise and to my disgust said "no".

Unbeknown to me at the time, a discussion about me took place at the wedding reception. Despite the age difference between Eric and me, my future mother-in-law, Dora Oldfield and her sister, Ida, from Etadunna Station, on the Track, had a long talk about which of their sons – Dora's Eric, or Ida's Bryan

– I should marry. It was very much like that for station people in those days. Class distinction was common in marriages and there were arranged marriages, marriages of convenience and sometimes, a mixture of both. In many cases, the decision came down to the acquisition of a housekeeper.

The years passed quickly after Dora's and Ida's private discussion. While I pursued my clerical duties during the day and worked as a theatre usherette three nights a week, I enjoyed a great social life. There were lots of dances and boys. I had the odd crush and finally fell madly in love with a Catholic boy, Graham. The relationship would never have worked because my father was a member of the Masons. In those days, putting a Catholic boy before my Freemason father was like waving a red flag at a bull. My relationship with Graham continued for a time but I knew my father disapproved. Eventually my realtionship with Graham ended.

What I did not fully understand at the time I met Eric was the extent to which the Oldfield family viewed life as a matter of property and money and the power such assets seem to bring. Eric and his cousin Bryan had it 'made' on their respective stations. The housemaids and governesses were seen by them as fair game. This was typical of households on many stations. I recall that on one, the wife of the station owner caught one of her house maids slipping into her son's bedroom. When she confronted the girl about it, the lass said she thought it was a part of her duties to keep the son happy. Many a young girl living in the presence of a good looking, virile young man, in such isolation, would be sorely tempted.

Eric fell in love with a girl nicknamed 'Rainbow'. Her

pseudonym fitted like a glove because Rainbow painted her fingernails different colours. Eric's romance to Rainbow was doomed to fail. No matter how strong their feelings were for one another, the Oldfield family long held the view that the family was in a different class than the likes of Rainbow, hired as a domestic worker. Eric's father made it perfectly clear to him that if he did not dismiss all thought of marrying Rainbow, he would lose his inheritance. My situation with Graham was, in a way, similar. The last straw for my dad came when Graham sent me a bunch of flowers and asked me to meet him in Canada where he was working. My father went berserk. Mum and Dad did not want their daughter to be too far away from the family home, although the Track was not exactly just down the road from Adelaide.

It was about that time that Eric's father, Claude Oldfield, who was then about 50 years old, developed a nasty skin condition which baffled doctors in Marree, so Claude and Dora travelled to Adelaide for treatment with Sturt Street based herbalist, Mahomet Allum. It became apparent that Claude's rash was an allergic reaction to something within his environment and he could no longer live in the Outback. Claude and Dora consequently bought a property called Nyroca Stud, at One Tree Hill, located about 35 kilometres north-east of Adelaide.

Racing and family celebrations gave me the opportunity to get to know Eric's sister Gwen and we became close friends. She accompanied her parents when they left Cowarie Station and decided to make Nyroca Stud, at One Tree Hill, their home. Like her brothers, while living in the Outback, Gwen did not

have the opportunity to go to Adelaide for schooling. Strangely, that did not change when she moved to Nyroca Stud. She continued her studies through correspondence and with the help of a governess. This limited her opportunities to socialise.

Unlike Eric, Gwen seemed to lack confidence and I know our friendship helped boost her esteem. The Oldfield's loved the races and the racing connection brought the two families together. I would see Gwen at the races in Adelaide, Gawler and Oakbank.

It was my cousin Joan Dunn who helped foster the racing connection between the Oldfields and the Burnards. As a result, I would visit Gwen and stay overnight and Gwen would reciprocate, coming to stay at our place in Semaphore Park and going to parties and dances with me. Soon, I was spending a little more time at Nyroca, seeing more of Gwen. I would occasionally see Eric when he came down from the station and we would spend time together.

It was December, 1958, when Eric came down from the station to stay at Nyroca, that the spark between us started to grow. We dated sporadically throughout 1959 when he came to the city. We also spent the Christmas holidays together. We enjoyed going to dinners, the movies, dances and nightclubs like our favourite, The Lido, a popular nightspot in Adelaide. Whenever Eric was down in Adelaide from the bush, we were inseparable.

Love was in the air.

Eric Oldfield

3

One day Eric and I were riding our horses along Semaphore beach when my horse tripped and rolled and I went headlong after him. It was a terrible fall. I hit the sand heavily and the horse rolled over me. Eric was very concerned, but after he realised that I was unhurt, he threw back his head and laughed. With no bones broken, I dusted off the sand and found myself joining the laughter.

Soon after coming home from a day at the races, Eric and I strolled on the beach. Eric looked at me and with a mischievous glint in his eye said, "I might as well marry you as anyone." I was in a dream, but it was all a bit unreal. I was frightened. I was about to go into the unknown. It was socially accepted in the 1950's that a girl aged 19 going on 20 was 'ripe' for marriage, lest she be 'left on the shelf.'

My first trip to the Outback, not long after Eric's proposal, proved to be an extraordinary experience. Eric's brother James, commonly called Jackson, who owned Mungeranie Station and his wife Nan (Nancy) were in Adelaide, visiting Jackson's parents, Claude and Dora Oldfield at Nyroca. It was arranged

that I return with them and have a good look at the sort of life I might expect living on a cattle station on the Birdsville Track. So I set off with them, along with their two children, sitting in the front of a utility. The rough, unsealed corridor of the Track was an experience in itself, but worse was to come. Unbeknown to me, the children had contracted measles and after having spent so many hours sitting beside the infected children, I too became a victim.

After a day or two at Mungeranie Station, we drove on to Cowarie Station where Eric met me. It was great to see him, but the dust storms brought me back to reality as my teacup filled with sand. It permeated everything, the things we touched and the food we ate. When we ate the corned beef, we could feel the crunch of sand between our teeth.

It was a couple of days later that Eric, who was in charge of the stock camp, left for a cattle muster. I wiled away the hours talking to Barbara Oldfield, wife of Claude Oldfield junior and Eric's brother. Eric and Claude junior co-jointly managed Cowarie Station after their father left because of his ill health.

The isolation of the Outback really hit me when I contracted measles. I discovered that children get over an attack of measles a whole lot easier than adults. I became very ill and thought I was going to die. There weren't any medicines in the medicine chest for my condition. Barbara Oldfield put me to bed in a darkened room and apart from her visits to bring a cup of tea, food, or clean clothes, I was left to fend for myself. There was talk of calling in the RFDS, but the service was called only in the event of a real emergency. Measles was considered way down the list, although getting measles at the age of 19

was not recommended. I had some terrible nose bleeds and I felt like death. Cherry, the housemaid at Cowarie Station, was amazed to find me hallucinating about spiders crawling up the wall. She rushed to tell Barbara, whose reply was typical of the people who lived in the Outback, "What we have, is what we have." In other words, if she survives she survives, if she dies she dies. The measles and the dreadful dust did not dampen my spirit. I was very headstrong. Come what may, I was going to marry this man, Eric Oldfield.

When Eric returned from the muster, he took one look at me and decided to drive me back to Adelaide that day. Eric stayed in Adelaide for the two weeks it took me to fully recover. During the first week, we spoke further about getting engaged. One day, he drove me into town to choose an engagement ring. When we got home I sat in the kitchen with mum, while Eric wandered outside to find dad, with the intention of asking his permission to marry his daughter. My father gave his blessing and so I could marry the man of my dreams.

The wedding date was set, but our plans to marry were brought forward when Eric had a disagreement with Claude, who was a hard task master, who some – particularly the young jackeroos – found almost impossible to please. Claude subsequently became sole owner of Cowarie Station and Eric the owner of Mungeranie Station – gifted by his parents as a wedding present. The youngest brother, Jackson, moved from Mungeranie to a property in the south-east.

My mother was cautious about my relationship with Eric and was concerned about the prospect of me going to live in the Outback, so she decided that she would travel to the Track with

me and check things out. On the train journey from Adelaide to Marree, we met Val Kruse, wife of the famous mailman, Tom Kruse. She was a lovely lady, but she must have wondered about me. I had no idea of bush life and was so immature. When I think back to those days, I must have looked like a lost soul. Mum had lots of doubts about what I was getting myself into and I guess I also had my doubts. I had no idea what love was really about. Was I in love or were my feelings merely infatuation? I had known Eric for such a short time – just those weeks during his brief visits to Adelaide.

Eric and I liked a property adjacent to Nyroca Stud and we initially dreamt of living there after making money from cattle at Mungeranie. Drought put paid to that idea, as it did to an opportunity later to buy Nyroca Stud. To think that the prominent pastoralist, sportsman and racehorse owner Homesdale 'Slinger' Nitschke, negotiated to buy that 840-acre prized piece of real estate, just 20 km north-east of Adelaide, for a song – a mere $80,000 – seems incredible. It was a steal and would be worth millions today. Slinger knew property values as his family ran a huge station, 'Hiltaba', 600km north-west of Adelaide. Slinger was also prominent in racing circles. He knew horses and is also installed in the South Australian Hall of Fame for cricket. He played many seasons of first-class cricket for South Australia, scoring 3320 runs at an average of 42.03 and played in two Tests alongside Don Bradman against South Africa in 1931-32. The plucky left-hander then performed modestly, with 53 runs at an average of 26.50. In another 'claim to fame', his horse, Dayana, made history by winning the derby in four

1. MY FIRST BOYFRIEND, ERIC AND I
2. MUM AND I OFF TO A WEDDING
3. MY GRANDPA
4. MY FRIEND SKIPPER

1

2

3

1. DAD & I GO FOR A RIDE
2. MARRIAGE LOOMS
3. SWEET & INNOCENT
4. RIDING THROUGH THE SANDHILLS
5. PATCH & MY WEDDING DAY.
6. MUNGERANIE POLICE STATION 1910

1. CAN'T LAND HERE
2. LAKE HARRY ON THE BIRDSVILLE TRACK
3. FIRST SIGHT OF MARREE HOTEL IN BACKGROUND

separate states, followed by his victory in the $100,000 1973 New Year's Day Perth Cup.

Eric and I finally settled on Mungeranie. Apart from the prospect of living and working in a landscape that Eric was accustomed to, Mungeranie provided another advantage – or so we thought at the time. It had an established, fully furnished homestead that we could move in to straight away.

Our marriage suited our families well. They more than approved. Jimmy Dunn was considered to be a part of the Oldfield family and cousin Joan had married him. It was a good 'fit' financially and socially. Due to the circumstances of property management, the wedding date was brought forward. I am sure tongues wagged. A hurried wedding in the 1960's meant only one thing – the bride must be pregnant. The old aunts would be taking notes and counting the months that the baby took to arrive.

After weeks of high wind and rain squalls at Semaphore, the front and back lawns of the family home were strewn with sodden peppercorn leaves on the day of our marriage. The trees stood forlorn, stripped of foliage, stark naked. Even the majestic old pine trees and wild peach trees which flanked our half circular driveway at the front of the house – trees that I had loved to climb as a child – were looking worse for wear. It was Saturday, June 25, 1960. It was cold at dawn, but happily, the morning was bright and sunny. I was to be married to the 'man of my dreams', Eric Oldfield.

While love bloomed in my mind, I was still apprehensive. I knew my life was going to change dramatically. I would be leaving all my favourite people and places in Adelaide and heading for a life in the Outback. It was a daunting prospect.

"Good morning," my Mum said with a bright smile as she breezed into my room, walked to the window and pulled up the old blind. "C'mon Val, stop dreaming. Get up! How can you stay in bed on a day like today?" The bright sunlight beamed onto my beautiful wedding dress which hung on the door of the old wardrobe. I stared at the dress I would soon be wearing. Soon I would be walking down the aisle to marry my handsome Eric.

My Mother was beautiful, her hair somehow shone like never before. This was my day, but it was also her day. Her only daughter was about to get married. Mum came back from the window and walked to my bedside. She smiled. For as long as I could remember I loved to jump out of the bed, rush to the window, pull up the blind and gaze at the sand dunes that stretched out beyond our house down to the seashore.

Today, my grandfather would be at the wedding. All of my grandparents had taught me so much about love and respect. My Bartlett grandparents had also instilled in me an appreciation of old things – antiques and heirlooms. Their big, old garden is forever etched on my memory. It had the tallest flowers and the biggest old trees I had seen. I loved running along the footpaths that seemed to twist and turn in all directions. You could immerse yourself in imagination there because it was like something out of Wizard of Oz. For a brief moment, I shuddered at the thought that I might never see them again.

In the hope that I might spring to my feet, mum tossed my ankle-length green chenille dressing gown onto the bed and said, "You know your grandfather is worried about you,

living all that way out there. I'm still worried. You'll be so far from dad and me – everything. I just hope you are doing the right thing!"

Mum had tried everything to get me out of bed. In sheer frustration, she blurted, "I give you five minutes and then I'll start the bath." Nothing was going to concern me on this day. I felt like a Queen and went to the hairdresser. On this, my day, I would take my time and do as I please. Mum stood and watched me. Her face was a picture. She was very proud, but was also a little sad. "Val, you've always loved looking out of the window . . . don't you want to do it one last time?" mum said, with her back to me and looking out of my bedroom window. Perhaps that would reassure her. Mum eventually left the room and I could hear the bath being drawn. I cuddled back into the luxuriant cool feel of my cotton pillow and dreamt of the man I loved, the man I would marry.

Mum came back into the room and said, "In your new house, you won't see the sea for a very long time. Will you miss it?" "Oh, Mum," I said stiffly, realising that my mother was as nervous as a kitten, "That doesn't matter. I know I am going to be so happy."

Finally Mum left and I 'floated' to the window and stared towards the sand dunes, my favourite playground. I loved our old, creaky weatherboard house with its shady veranda and high ceilings. I loved our garden with its myriad of tall flowers, lush green lawn and the giant old peppercorn tree. My mind turned to those happy, carefree days growing up in the house – wonderful days of playing with my friends at the beach, exercising my dad's horses in the sand hills, riding

beside John Letts, going to school, the balls and dinners, dancing at the Largs Bay Sailing Club and my terrific job which I loved, working as an usherette at the Ozone Theatre. Among the happiest memories were our winters' nights' treats; sitting before a roaring open fire in the lounge-room, sipping hot cocoa and eating Dad's special toast and Mum's cup cakes.

Today was my wedding day and I needed to get myself ready. The wedding photographer was due in a couple of hours and I began to worry how the young man would cope with our dog Patch, whose anger knew no bounds when any stranger dared step on his territory. The wind made the house creak, a familiar sound. It was funny how a creaking, groaning weatherboard house could provide some comfort to a girl about to be swept off her feet.

After all the rain, there were few dry spots on the lawns and Patch aside, the photographer would have his work cut out finding suitable sites to ensure a balanced photograph. I cannot think why no one bothered to tie Patch up. Any stranger found him to be a vicious little thing. The instant Patch set eyes on Dave, the photographer, Patch bared his teeth and snarled with ominous intent. When Dave tried, in vain, to dissuade him from sitting on the edge of my wedding dress as I stood on the back lawn, Patch gave Dave the evil eye. At one stage, I found I was yelling at Dave, "Don't get any closer or Patch will have you!" Dave kept his distance. Patch relaxed and thrust his leg straight out in front of him as if to convey to Dave that he should think twice about messing with him. I decided then that Patch, as a member of the family, should feature in all the pre-wedding photographs and that is how it turned out. Dave,

the photographer, was happy because I was happy and Patch was happy with the photographer because he kept his distance and allowed him to do exactly as he wished.

The moment Dad and I arrived at the church, it began to rain, yet nothing was going to dampen my spirits on this special day. Dad was very proud as I took hold of his arm and walked me down the aisle. Dad always wanted the best for his daughter and for her to be loved and cared for as he had looked after me in my early years. My marriage into the rich Oldfield 'dynasty' was something he seemed to relish. On the other hand, my mum just wanted me to marry a man who would make me happy forever more.

There were so many people in the church, all with happy faces and smiling. Eric turned and looked at me. His smile lit up his face and I found it hard to believe that I was going to have this wonderful man as my husband. His healthy tan contrasted with the paleness of many of the guests in the church. It was easy to see Eric was an outdoors man.

At the reception, the band played and we moved about the dance floor, Eric gazing into my eyes. I knew he really loved me and I felt happy and complete. I was starry-eyed. We were also beside ourselves with excitement because we were about to spend our honeymoon staying in five star luxury, at the newly built Chevron Hotel in Surfers' Paradise, which was sheer heaven.

We spent three glorious weeks on honeymoon at Surfers. We wined (I loved champagne) and dined and got to know each other better. I found there were many things to do and see on the Gold Coast. I was a naïve girl. Having no idea at all

about sex, I firmly believed that if you did 'it' once you were automatically pregnant.

Innocent and totally ignorant of the ways of the world and certainly unprepared for bush life, I was about to enter a new, brave world. I was the youngest child in our family and subsequently very spoilt. I was wrapped in cotton wool, almost certainly because Mum and Dad had the tragedy of losing their first-born, Bob, when he was aged just 10 years. I was also headstrong, which Dad managed to tone down to a degree. However, this determined nature gave me the inner strength to face the challenges I was later forced to confront.

When our honeymoon ended, we flew home, visited my parents briefly, borrowed a utility and stacked a trailer with wedding presents – even a washing machine – to head for Marree, the southern most tip of the Track. I sensed everything would turn out okay because I was married to the man I loved – my man of the Outback.

Outback Terror

4

Dorothea Mackellar died in 1968, after the time of the snake attack at Mungeranie Station. Just before I married, I had been to the Track, but most of my time was spent in a darkened room at Cowarie Station, marking time as my 19-year-old body fought measles. For days, my only and infrequent visitor was Barbara Oldfield, bringing me a cup of tea, or to change the bedding. What did I really know about the Outback: its history, the danger? I was a starry-eyed, love-struck city girl, who had led a pampered existence. I had never even stooped to pick up a duster, swept the leaves off a path, or vacuumed a room. I had literally laughed and danced blissfully through my teenage years. When I look back, I realise my mother, especially, was too lenient on me. Her only daughter was allowed to pretty much do as she pleased. There were no home duties for this little Miss. Life was a breeze. There were dinners, dances and boys – lots of good-looking young men – but I only had eyes for one man, Eric Oldfield. His love meant the world to me and wherever the man of my dreams decided to go, I would go.

Eric Oldfield was part of an Outback dynasty. The Oldfield

> I love a sunburnt country,
> A land of sweeping plains,
> Of rugged mountain ranges,
> Of droughts and flooding rains.
> I love her far horizons,
> I love her jewel sea,
> Her beauty and her terror –
> The wide brown land for me

Excerpt from *My Country*, by Dorothea Mackellar

Dorothea Mackellar's immortal poem, My Country, resonates with all those stoic souls who lived and worked on the Track.

family owned and seemed to 'control' The Track. There was an Oldfield, or a close relative, at just about every station dotted along the track and within cooee of that famous 514 kilometre road traversing the Strzelecki Desert to link Marree in the south with Birdsville in the north.

The rough Track had been hewn in the 1880's when it became the main stock route. At the height of the droving days, it took a month to bring cattle all the way along the Track from

Birdsville to the railhead at Marree, or Hergott Springs as it was originally called. It's name was changed during World War I, due to anti-German sentiments. The drovers and stockmen were tough as old boots. Despite the heat and dirt, I'm sure they would not have swapped their lives for quids, marvelling at the magnificent blue skies and the spectacular thunder storms and lightning strikes that captured Mackellar's heart. To survive, these men worked hard and they played hard. Eric Oldfield was very much one of them.

When Eric's parents moved to Adelaide, Eric and his brother Claude (Jnr) initially ran Cowarie Station on the Track. Eric was in charge of the camp and Claude, the homestead. For years, Eric had been a drover, pushing cattle through some of the most treacherous and unforgiving territory on the planet, across shifting sand hills, stony plains and the flat, dry beds of ancient rivers and streams. Like others of this land, he was strong, muscled and browned to perfection by the Outback sun.

Once, Eric told a reporter covering a cattle drive for a Sydney-based newspaper how one could tell if a drover was good at his job. Eric scratched his chin, slowly extracted tobacco from a tin of Log Cabin, rolled a cigarette and lit it. After a deep draw and long pause he said, "You know a good drover by cattle shit. A good drover will allow the cattle to stand for a stretch and give it time to have a shit before he moves them on. When your camp has lots of neat piles of shit about the place, you know you are in the company of a good drover. Cattle are like people. They need to relax when they awaken, take time to have a shit, refresh. You can tell a bad drover if there's cow shit spread for hundreds of metres along the track, out of

camp." Such 'pearls' of wisdom come from years on the Track. Eric was always refined when he spoke with me, but I guess it was different with the boys on a cattle drive; the language they used when they chatted.

It was not until I lived on the Track, that I came to understand its dangers and the craftiness of those who survived and thrived there. Many perished. Among them was the Page family. Ernest, 48, his wife, Emma, 45, and two sons, Douglas, 12 and Gordon, 10, set off from Marree, 647 kilometres north of Adelaide, in their 1957 Ford Customline in search of a new life in Birdsville, or beyond, in 1963. Ernest had been a middle-aged '£10 Pom', who had sailed from England to Australia about four years earlier. Why the family chose to live in such an unyielding environment, is a mystery.

Apparently, Ernest eventually lost his job at the garage because he talked too much to customers. At the height of summer, when stations were typically abandoned, he subsequently hitched a trailer to his petrol guzzling Customline with jerry cans of water, food and camping equipment. With station owners seeking refuge in cooler places, like Adelaide, radio communications along the Track were broken. The Pages could not radio through to homesteads to tell them of their expected departure and arrival times in various areas, which was the usual precautionary practice in the Outback.

The Page's vehicle was capable of 80km per hour on the open road, but the family drove north into the heart of an unforgiving land of drifting and at times blinding sand, melaleucas, coolabah trees, gibber stone plains and temperatures so hot, that even in the shade they seared the soul. The stress to

the Customline's engine just from negotiating the Mungeranie Sandhill, would have been diabolical. In addition to this, in gibber country, near Mungeranie Station, the vehicle had to trundle over a veritable sea of marbles. These red and yellow stones were polished to a high sheen by thousands years of wind-blasting sand. They were tossed up by Ernest's car wheels and gunned the undercarriage and sides of the car.

At the time, the eldest boy, Robert, 19, was a jackaroo at Clifton Hills Station, a vast 23,000 square kilometre cattle station, 324 kilometres north of Marree and about 170 kilometres south of Birdsville. Robert wanted to travel to Marree for Christmas. He hitched a ride with another 'local', Noel Glass, who drove a vehicle for Track identity, Pat Smith. Pat had bought the Track mail run from Tom Kruse, two months before the Page's journey. As Glass drove Robert Page south towards Marree, they were approaching Etadunna Station when Robert recognised the vehicle coming the other way. He knew it was his father's car and Glass stopped so everyone could chat. Robert had not known of his father's plan to head north. After some discussion, Robert threw his swag in with his family and decided to go north with them. When the Page family reached Cooper Creek, usually a five kilometre wide sandy furrow scooped from the ancient landscape, the punt manager, Ernie Pake, got them across the water. Pake was the last man to see the Page family alive.

It seems the Page's US vehicle had been converted from left-hand to right-hand drive. It had an automatic gearbox that was fitted with a wide, flat steel bar, which ran from one side of the gearbox to the other. During work to convert the vehicle

to right-hand drive, the bar was placed under the gearbox. This was to make it easier to select gears from the driver's seat on the right-hand side of the vehicle. However, the modification to the car and the welding job had to have been the work of Ernest Page, which it was to prove significant as it was likely to have been the greatest factor in the Page family's demise. Driving over the harsh red and yellow gibber stones, the stones whipped up by the wheels played havoc with the Ford Customline's specially fitted bar on the gearbox. The bar was damaged beyond repair and therefore Ernest was unable to get out of second gear. This placed further strain on the engine and resulted in an enormous drain on fuel.

The Pages ran out of petrol on the Diamantina floodplain, close to Deadman's Sandhill. They managed to walk a few kilometres to Turkey's Nest Dam and returned, with an 18 litre drum of water , to the rest of the family waiting at the car. Unbeknown to Ernest and Robert, two 200 litre (44-gallon) drums, filled with good drinking water for the use of station ringers working in the area, stood untouched at the dam. When people are at risk of dying of thirst in extreme temperatures – very hot or ice cold – there is a dilemma to overcome. Any water they find can be inexplicably unpalatable because its temperature can be extreme. This was referred to by a survivor of the jet liner which crashed in the Andes and who was among those who lived by eating the flesh of his dead companions. Nando Parrado's Miracle in the Andes (Orion, 2006) explained, "People always want to talk about the hunger, but the thirst and the cold were much worse for me. Our lips were cracked and bleeding and every drop of cold water was painful to drink."

It is likely that after hours of frustrated talk at the car and inevitable thoughts of Christmas, Ernest and Robert knew their situation was becomingly increasingly desperate. Robert knew the area and it is thought he persuaded his father to accompany him to seek help by walking to Clifton Hills Station. Locals in Marree would later attest that when Ernest Page worked as a mechanic at Marree, he was forever telling visitors and tourists "never leave your car if you get lost in the Outback." Sadly and tragically, Ernest Page broke his own golden rule.

During the search for the Page family, nightly temperatures on the Track exceeded 40 degrees Celsius. Sergeant Dowling of the Port Augusta Police said, "We had plenty of water while we were out there, but this doesn't mean you can drink it. It gets so hot you can't bear it in your mouth. It gets just as hot in the water holes."

Ernest Page's abandoned car was found on Sunday, December 29, 1963. An RAAF DC3 flew from Edinburgh Air Force Base, near Adelaide, to conduct a grid-pattern aerial search. Four bodies were spotted lying under a coolabah tree. They probably perished on Boxing Day, 1963, although they were not found until New Year's Eve. Ernest, his wife Emma, Douglas and Gordon were all deceased. Black trackers believe that Robert Page – the eldest son – placed the bodies of his family under the coolabah trees as they died. Robert had tried to climb over Deadman's Sandhill. He hung his shirt on a small tree and tried to hide from the intense heat of the sun by digging a ditch, but tragically, like the rest of his family, he perished. The newspapers were full of reports of the tragedy.

The ability of Aboriginals to survive in such a parched land was remarkable as water was always an issue for people living on, or travelling along the Track. People could and still get stranded by a flash flood, or perish in total isolation. That appears to have been the fate of one group of travellers, revealed in 1920 by six Aborigines while mustering horses in the Simpson Desert. They came upon an old bullock wagon, partly covered in sand. Inside was the body of a child, its skeleton preserved intact by the shifting sands. After wrapping the body in bark and completely covering it with twigs and gum leaves, the Aborigines buried it in a sand hill and heaped stones over the top, creating a monument to the child's short life.

Years later, the Aboriginal stockmen told some white folk of their find. Through the 'bush telegraph', one person told another and so the legend grew. Eventually, government officials got wind of the story and they decided to investigate. Four geologists were sent looking for the site. Finding it proved difficult. They arrived at the spot marked on an old map, but there was no sign of the buried wagon. Finally, they found a wagon wheel in the stony desert and discovered the buried child, still wrapped in the burial garb the Aboriginals had respectfully provided.

Before I moved to the Track, Eric told my Mother and me about another death, which given my lack of understanding and appreciation of the ways of the Outback, seemed bizarre. His words were along the lines of, "Sometimes on a long muster, which took up to two months, the Aboriginal jillaroos rode with the stockmen. One muster, on Cowarie Station, there were two Aboriginal girls and I discovered one of the women

was pregnant. I told the young woman that the baby would be looked after. A bit later the pregnant girl yelled, 'Boss, I'll catch you up a bit later.' She rode from the outfit and disappeared. She had ridden off to give birth. Days later, when she finally rejoined the muster, we couldn't see her baby and we questioned her. 'Him no good, Boss. Had to leave 'im behind in the bush,' she said." We were shocked and Mum later queried whether I could and wanted to live in such a harsh environment. I assured her I wasn't daunted at the prospect of marrying Eric and living with him on a remote station. Yes, I told my Mother, the bush was another world and one had to accept the lifestyle – the good and the bad. I now concede that while I felt I was up for the challenge, in hindsight, my notions were somewhat romantic. Regardless, I knew that at the time I was determined to make a success of my life and be an Outback woman.

No doubt a sense of safer travel, other than horses, wagons and coaches, came when a chap called Harry Ding began a fortnightly mail run, with legendry mailman Tom Kruse at the vehicle's helm, in 1936, from Marree to Birdsville. The Track was only sketchily marked between bores. Harry charged people 'twopence a pound' to take goods to Birdsville and a '£5' for a passenger to make the journey. Passengers were expected to bring their own supplies of food and a swag – two blankets rolled up inside a waterproof ground sheet.

Before 1926, the mail was delivered by a coach and four horses. Fresh horses were allocated on stations along the Track. Some famous names of the region – Doug Scobie, Allan Crombie and Harry Williams – brought trucks and utilities to the Outback ultimately making the mail run more efficient and

reliable, however drivers had to 'know their stuff'. The Track running south-southwest to north-northeast and the prevailing wind tending to come from the west, the wind created sand hills cutting across the track. The slope on the windward side was typically gentle, but a dangerous near vertical drop was on the other side of the crest. Even for an experienced driver, negotiating these sand hills was tricky. There were no second chances. If the driver did not manoeuvre his vehicle up the gentle slope at the right speed and slip slowly over the crest and down the vertical side, it was disastrous.

People like Tom Kruse, who bought the business from Harry in 1947, became an 'old hand' at mastering the task, but he always approached it with care. Tom drove a six-wheeled Leyland Badger, now in the National Motor Museum at Birdwood, on the mail run at the outset. Laden with mail, newspapers, fuel and foodstuffs, he left Marree at 11am on January 1, 1936, for his first crossing.

Tom used to recall that his wife, Valma, whose parents owned the sheep property, Wabricoola, near Yunta, had exclaimed upon seeing Marree for the first time. "Oh my God, Tom. What a place. If I die, please don't bury me here." At the time, they were moving to Marree and ultimately lived near the general store, where you could buy just about anything from coffee to kerosene.

Tom knew many descendants of the Afghan camel drivers (cameleers) of the Outback who first carted goods between stations. They were tough men who helped carve out a future for themselves and their families, far from their homeland on the Pakistan-Afghanistan border. They first came, along with

1

2

1. DROVING CATTLE
2. THE PAGE FAMILY'S VEHICLE
3. THE CAMP
4. NO FLIES ON ME
5. BORE-HEAD – DAD, MUM, SUSAN & I
6. MY FRIEND SKIPPER
7. SNOWY, UNCLE DICK FRICKER & BILL GWYDIR.

6

7

1. PUTTING HOBBLE STRAPS ON HORSES
2. PETER JEFFS ON A 'BUCKJUMPER'
3. SUSAN AMONGST THE WILDFLOWERS

122 camels from Karachi, to South Australia in 1822 and became a 'fixture' on the landscape, transporting goods, for 60 years. Australia's most famous train, The Ghan, is named after them.

Descendants of the Afghans lived in self-imposed segregated family groups on the southern side of the Marree railway track in the mid 1900's. They prayed at the town Mosque until it was demolished in 1956. A lot of the cameleers who came to Australia married Aboriginal women. They lived in what the locals called 'Ghan towns', complete with Mosque, halal butcher and Imam (holy man).

An English Immigrant, Winifred Stegar, arrived in the outback in late 1800's, having been brought up in an English-run orphanage in China. Winfred fell in love with German and they had four children over nine years of a marriage but Winifred was very unhappy. She found her husband was 'rough, rude, drunken and violent'. Winifred got a job in a hotel in Mungallala in Queensland and on March 10, 1915, wrote in her diary, "There's a hawker who calls here… an Indian named Ali. He comes into the kitchen and I make him a cup of tea". The next day, Winifred noted, "Ali came in again today. He has the most beautiful brown eyes and white teeth. He calls me 'mem-sahib' and treats me with respect. Sometimes he wears a turban and baggy pants and a waistcoat. He looks different from the drovers… some of them don't like him and call him, 'that bloody Afghan'". Six months later, Ali walked into Winifred's kitchen, held out his hand and said, "Come with me and be my wife". Ali and Winifred married and had three children. They had a marvellous life together, but there was also sadness. She wrote a book on their life

together, entitled *Always Bells, Life with Ali* (Winifred Stegar, Angus and Robertson, 1969).

The area of the Track became famous in Australia when, in 1871, the cattle thief who became known as Captain Starlight, drove 1000 head of stolen cattle across the Strzelecki Track, from Lyndhurst to Innaminka and then all the way to Adelaide. Given the landscape, it was an immense, although illegal, undertaking.

These tales, characters and the landscape, formed the backdrop to my life at Mungeranie and other lives on the Track. The sheer isolation of the Outback, with its heart-breaking droughts and breaking rains and the characters who tried to tame it, flood my memory with a strange mix of fascination, joy and sadness.

Mungeranie: 'Big Ugly Face'.

5

With our wedding and honeymoon in Surfers' Paradise behind us, it was time to start married life at Mungeranie Station located on the edge of the Sturt Stony, Tirari, Simpson and Strezelecki Deserts and beside the Derwent River. We set off, in a borrowed utility with a trailer, from Nyroca Stud. Everything was stacked to capacity. We stuffed straw around the breakables and packed the wedding presents in big crates which were stacked on the trailer. All went well until just out of Leigh Creek. I was driving too fast and hit a bump in the road, causing one of the big crates to fall onto the highway. Eric was asleep, but at the sound of the crash he awoke and was none too happy with the scene of scattered and broken crockery that littered the road. Darkness had set in and we searched the road by the light of our headlamps. We carried the gifts we could salvage back to the vehicle and piled the presents between us in the cabin. The next few hundred kilometres were decidedly uncomfortable.

It was about a 12 hours drive to Mungeranie Station, 204 kilometres north of Marree, from Adelaide. Today it is the only

fuel and supplies depot on the Track with a much needed hotel and an up-to-date air strip. The word Mungeranie is based on an Aboriginal word meaning 'big ugly face'.

Driving on the Birdsville Track at night was not a wise option, so we stayed overnight at Joan and Jimmy Dunn's place in Marree, where they then ran the general store. Next morning, we drove to Mungeranie homestead, set back about 300 metres from the Track and hidden from the road by a huge sandhill, it reminded me of home.

To reach the homestead, we drove from the road, over the sand hill and on to a rough road of red gibber stones, passing some old ruins that were once a police station and later served as a pig sty. A corrugated-iron fence surrounded the house, which by Outback standards was huge and sturdy, with 45 centimetre (18 inch) thick stone walls.

Inside the home, there was a big master bedroom, a long and narrow sitting room, two extra bedrooms, a large kitchen with windows, a dining room and a bathroom in one corner of the enclosed veranda, which ran around the house. A breezeway ran through the middle of the house. There were few windows to limit dust inundating the home and doors that opened to the verandah. The house was basically square and more of a fortress than homely. It was pretty dark inside. We later enclosed more of the verandah and added extra rooms, including a classroom for the children and a large guest room, and governess and maids' quarter.

When I walked into the kitchen, I was met with an unbelievable smell, like rotten eggs. I thought there was a dead body in the kitchen. Eric explained that the unpleasant

odour emanated from the bore water, fed by the Great Artesian Basin, which was the source of our household water, with the exception of drinking water, which came from rain water tanks. Later, we bought a tank, where the Artesian bore water was 'aired'. At times, however, you had to scrape the green slime off the surface of the water and once I retrieved a dead crow from its slimy depths. We had been cooking with this water.

If first impressions were anything to go by, I was less than happy about the state of the kitchen. Although there were windows, there were no views of the outside from it. Similarly, there were no views from the sitting room as the windows were covered by heavy drapes. I was not used to living in a house with hardly any windows. While their lacking prevented the house from heating up quickly during the summer, once the house became hot it took a long time to cool down. In summer, it seemed to pulse with heat for weeks and sometimes months. The verandah was no 'less inviting' as wire mesh enclosed it. Eric said it helped keep out the flies and dust, plus the odd adventurous dingo, or wildcat.

As I walked through the house, I found gum leaves strewn on the floor in the sitting room open fireplace. At first, I thought someone had tried to decorate the fireplace – that was before a piercing screech and a loud scurrying noise came from the chimney. I was about to look up the chimney when leaves, feathers, eggs and twigs fell in a cloud of dust, followed by a terrified pink and grey galah, flapping its wings like a helicopter in a wind storm. The galah couldn't find a way out of the room and was frantic. I hunched over, shut my eyes and covered my head with my hands. I knew all about magpies and how they

NO BEATING ABOUT THE BUSH

could swoop and peck, but I had little knowledge of galahs. What I did know was that a frightened animal could potentially scratch and claw to survive. I feared a bird attack, like something out of an Alfred Hitchcock horror movie. As the bird flew madly about the sitting room, I ducked out to find Eric blissfully asleep on our bed. He was oblivious to the outbreak of World War III happening to me in the very next room.

I probably needed a stiff drink, but I settled for a breath of fresh air. I wandered outside and took in the vast panorama that was Mungeranie Station. It was night, but the moon shone so brightly it lit up the land. There was one consoling feature I could see – something that reminded me of my seaside home in Adelaide – a big sand hill, the one we drove over as we came into the station. However, I felt isolated and my mood didn't brighten when I spotted some strange tracks in the dust. I followed the tracks, which led me right the way around the homestead. I was scared, thinking they were made by a snake or perhaps a family of snakes. I ran into our bedroom and shook Eric, who was still sleeping. He casually opened one eye and said, "What's up?"

I yelled excitedly, "Eric, Eric we're surrounded by deadly snakes. I've seen their tracks. They run right round the house!" "No, Val, that's nothing," said Eric. "They're goannas. Goanna tracks, Val, they're harmless."

A few days later, I went outside to dump some rubbish and out of the bin sprang a huge goanna. I screamed and ran. Skipper, our Border Collie, snapped at the reptile, but decided discretion was the better part of valour and took off back to the homestead. I was right behind Skipper and the goanna was

chasing me. When a goanna senses danger, its instinct is to climb a tree. I was later told that had I stood still, the goanna would have clawed its way up my legs and sat on my head. Skipper and I got through two wire doors and the goanna was still behind me. At last, I got through the wooden door also and my pursuer didn't gain entry to the main part of the house. The goanna was quickly dispatched by a worker on the property and our Aboriginal workers skinned the beast and cooked up a handsome evening meal, much to their delight.

Little time had passed since I first arrived at Mungeranie, when some of Eric's relatives arrived from Queensland. I was proud of the decorative touches I had made to the house and I volunteered to give Eric's aunty an escorted tour of the home. She complimented me on my good taste and then went into a detailed discourse about which relative had died in which room

and at what time in the Oldfield family history. This news was a touch unsettling for a young bride and I couldn't wait for the escorted 'tour' of my new home to end.

At Mungeranie, we used rainwater collected in two tanks connected to the house for drinking but the same water killed all my fish in the aquarium. After inspecting the tanks, we found that one of them had turned brackish from gum leaves that had rotted in the water. That meant just one tank was suitable for supplying drinking water.

We used our artesian bore water for evening baths. The bath had to be filled in the morning because the scalding water from the bore drain did not cool down with the sun beating down on the 1.5 kilometre pipe linking the bore head to the station homestead. At its source, water gushed at 27,277 litres an hour. It gouged a huge hole at the bore head and the

water was so hot, travelling drovers cooked their meat in it. The overflow rushed 10.2 kilometres down the bore drain before flowing into the Derwent riverbed. Some of the bore drains closer to the Track attracted tourists and some lost their pets. Dogs would jump out of a tourist's car and dive into the scalding water. Warning signs are now placed at all bore heads in the Outback, because of the danger to domestic animals.

The bore drain meant danger, but it was also a life-giving force. Cattle would follow the feed that grew along the banks of the bore drain. If there was feed near the water, so much the better as the mob would tend to stay in one place. When feed became scarce near a dam or other water source, a cow would become the designated 'babysitter' for the calves while the mob wandered in search of greener pastures. The cows took the task in turns. One cow could be looking after 10 calves at a time. The main concern was dingo attacks. If a dingo bit a calf, the wound would become fly blown and it was the beginning of the end for the poor calf.

The light and power for the homestead were supplied by a bank of batteries and wind power. Power was generated by a windmill, standing above an 18 metre tower, charging the batteries. We used a diesel engine to generate extra power. One day when Eric and the other boys were away in camp, I taught my Aboriginal housemaid, Maisy, how to help me start the diesel engine, in a shed, under the tower. "I'll show you what to do, Maisy," I said. There was a big handle attached to the 32-volt engine that had to be turned. However, to get the engine going, one had to be quick to pull the compressor lever down and remove a petrol-soaked rag, strategically placed

over the air filter. Timing was critical to the success of this operation. I turned the handle. "Right, Maisy, right… hurry," I said. However, Maisy was not so quick with her hands and there was an almighty bang. We had blown the side out of the engine. Bits of metal machine-gunned around the room. It was a miracle neither of us was hurt.

Early on at Mungeranie, we had the 'long drop' toilet near the house and a chook had fallen into the hole. It became disconcerting to everyone who visited the toilet, for there was a chook looking up with one beady eye trained on you. I asked for help about this on what we called the cockatoo session – a chat session between women at the station in the Outback on our wireless – and Aunty Ida Oldfield came up with the solution. "Lower a stick of bamboo down the hole and the chook will climb out," she said confidently. Aunty Ida was right. The chook escaped, badly soiled, but in excellent health.

It was terrific to hear familiar voices over the radio, but invariably there was little news and nothing but small talk. The conversations always seemed to get around to the direction of the wind. I never knew which way the wind was blowing at Mungeranie, let alone on the other stations.

An Outback woman was expected to know how to keep house, cook and clean the homestead. When I first arrived at Mungeranie, I had no idea about cooking, but I was determined to make a go of it. Armed with my school cookbook and faithfully following the instructions, I went through each of the recipes, but nothing turned out too well. I'm sure that out of kindness, Eric said nothing. Eric, in fact, was a far better cook than me. He had 'batched' at Cowarie for a number of years and could cook a mean roast and even cakes. Eric was capable in many ways.

I was also determined to do all the domestic chores. My stoic attitude had me cleaning every room, every day, by myself. Each night I fell into bed utterly exhausted. I really thought that was the 'norm'. After all, I held down three jobs in Semaphore and was able to do all that and lead a busy social life.

One could not jump into the car and rush down to the local shop at Mungeranie. Bread was needed daily for breakfast, morning and afternoon teas, as well as smokos – when workers stopped for a break – lunch and dinner. The Outback wife was judged on her expertise in making bread. All the station wives wanted to produce the best bread and Aunty Vi Scobie from Mulka Station had a reputation as being the best bread maker along the Track. Her bread was the benchmark, so I was thrilled to have her in our home to teach me the art. Our bread was

made from a potato yeast starter, made from hops. Potatoes were peeled, washed, thinly sliced, then boiled and left to cool. Later, flour and sugar were mixed in with the mashed potatoes. Lastly, the potato starter was folded in for the yeast to ferment. Then the main bread making could begin. Prior to Aunty Vi Scobie's 'lesson', my first attempt at making bread was something of a disaster – I had let the dough stand far too long. News of my effort spread like wildfire. At least it gave people something to talk about.

My other great cooking disaster, which was never to be repeated, was in cooking gravy for steak which everyone on the station had for breakfast. On one occasion, when we had guests, I decided to use some 'Gravox' – left at Mungeranie by Eric's sister in law, Nan Oldfield- rather than making my own gravy. It wouldn't thicken so I added some more. It was quite a soup by the time I had finished. I served the meal with aplomb but my pride was quickly 'deflated' when the guests rushed for water after taking a couple of mouthfuls. It was then that I realised the tin marked 'Gravox' was in fact, cayenne pepper.

Cooking in preparation to take food on a muster, known in the Outback as camp cooking, was also something I needed to learn. When stockmen left on a muster, they needed to take sufficient supplies – bread, cakes, tarts and cooked meat – in their saddlebags – to sustain them in camp for the first few days. Then the horse tailer took over the cooking, as well as hobbling the horses at night.

To me, the only exciting thing about cooking was being able to use a pressure cooker, although it was very 'temperamental'. It would happily hiss away but if it built too much pressure, the

safety valve blew and the contents would spew like an erupting volcano. Steaming hot pea and ham soup hanging from the ceiling in oddly shaped lumps was not a good look.

Another 'technical' problem I later faced was that the back of the wood stove burnt out and the oven hardly retained any heat – certainly not enough for bread making. My dad came to my rescue. He asked Eric if it would be okay for him to give me a Portagas stove. After our new stove was installed, our governesses got into the habit of bringing the children out from school lessons for a 'toasty' – toasted bread, topped with cheese and tomato. On one occasion, we had a new governess and I gave her instructions on how to use the stove, telling her to put the stove on for ten minutes and then place the food in to be grilled. Instead, the girl turned the gas on, left it for ten minutes, then returned and lit it with a match. The explosion nearly blew her head off. The situation reminds me of one lad, who hailed from Adelaide, who came to work with Eric as a jackaroo. He was asked to 'put the water on the fire', meaning that he was to boil the billy over the flames. This lad took the billy and threw the water over the fire.

Stoves were not the only things that posed potential problems. Fridges did too. Eric went out for a few hours and when he returned he found me sitting on the floor looking at our kerosene refrigerator. He asked what I was doing. "Oh, there's a flame that is going back and forth along the bottom of that thing…" I said.

"My God," he yelled, cutting me short, "Get clear of that thing, it's about to blow up!" I had no idea that a refrigerator could explode. Eric moved it out on to the verandah and a few

MUNGERANIE: 'BIG UGLY FACE.'

weeks later it blew up. In doing so, it burnt a good deal of the verandah and destroyed part of the laundry. How lucky was I?

While Mungeranie homestead was a 'workable' house, with the breezeway aiding air circulation, it was extremely hot in summer. We had a monster of an evaporative air-conditioner which resembled a large concrete mixer. Unfortunately, it added to the humidity at times. Eventually, we purchased a new water air conditioner – ironically called a Breezeway. With just one water tank used exclusively for drinking and cooking, we had to use bore water for the air conditioner. We would sleep with the Breezeway going all night but in the morning we would wake with raging sore throats and covered in white spots, from soda carried by the bore water.

Sleeping out on the verandah proved a better way to go. If there was a slight breeze, or cooler weather, we felt the benefit of it. I wondered why houses in the Outback were not all built underground, as they have done in some of the opal mining towns, such as Coober Pedy. These houses are wonderfully cool in summer and warm in the coldest of winter months.

During the winter, I found the range in temperatures in the Outback amazing. Overnight, it could be freezing and the following day, the weather was just pleasantly warm, to very hot. When the weather changed late in the day, we rushed to get our woollies on.

Overall, our daily adaptations to cope with the harsh environment were relatively simple but I often wondered how the pioneers of the area, who did not have access to the infrastructure we had, coped with the harsh environment. The sinking of a government well at Mungeranie in 1883 would have

been a boon to them. According to Flinders Ranges Research (www.southaustralianhistory.com.au), facilities developed when Richard Forbes Sullivan and his wife opened a store, eating house and hotel at Mungeranie in 1886. It would have been a difficult operation for them but they supplied shepherds, drovers, travellers and surrounding station people with most of their daily needs.

Flinders Ranges Research also cites William Crombie, George 'Poddy' Aiston and Jack Ridge as being among characters who made indelible impressions on Mungeranie. Crombie, who bought a block of land at Mungeranie in 1888, built three homesteads – two of them falling victims to flooding – for his huge family of children. He worked his cattle station at Mungeranie, which was then only 600 square kilometres, carrying up to 500 breeding cows. Top market price at that time was £8 for bullocks and £5 for steers. Mungeranie, at the time of the Crombie, became a thriving little township, with a police station and was a venue for picnics, dances, social tennis on the homestead's lawn court, school and race meetings which always attracted at least 400 potential punters.

Aiston, a policeman and an ethnographer, was stationed at Mungeranie from 1912 to 1924. He distributed rations, levied bore fees, inspected stock, collected dingo scalps, registered births, deaths and marriages, processed mail and issued licences. In addition, in what was probably his most important role in life, he studied the customs, beliefs and technology of the local indigenous people. An authority on central Australian Aboriginals, particularly the Wangkangurru people of Eastern Lake Eyre, Aiston photographed secular and

ceremonial activities, plus landscapes of the area and life in general of those on the Track. Aiston bought the Mulka store upon retiring from the force, leasing the government bore and selling water at 'a penny a drink'.

Jack Ridge then stepped in at Mungeranie. He was Crown Lands Ranger, Issuer of Aborigines' Rations and Receiver of Wild Dog Scalps, among many things. One 'dogger', Jack Ward, collected 3000 dingo scalps in one calendar year. Officer Ridge's abiding memory of Mungeranie was not the impressive stone house and tennis court amid splendid grounds, but the size and colour of the centipedes. Ridge reckoned they grew to 27.5 centimetres long and were 3.2 centimetres wide with dark green stripes. He was not exaggerating. They, along with a variety of spiders, would invade our house during dust storms.

Luckily, when I first arrived at Mungeranie, although the creepy crawlies, reptiles and dust made an impression, the homestead and its facilities were workable and I realized they were better than many on other stations. The artesian bore was a blessing. In contrast, at Kalamurina Station, operated by Joan and Jimmy Dunn, water was always scarce. The Dunns often came to the Mungeranie bore head to cart water home. Similarly, at Cowarie Station, the water from their bore was so poor and hard that one's hair would be stiff with salts from the water after washing it. The Kalamurina homestead wasn't a source of celebration either. It was comprised of a large stone room and a bedroom. There was also a washhouse at the back. Furnishings were sparse and their existence seemed Spartan. I know that Joan's father, Uncle Clarrie, was horrified when he discovered his daughter would be living in such conditions

after marrying Jimmy. Jimmy later built Joan a lovely new home at Kalamurina.

When I arrived at Mungeranie and in my early days there, the area looked relatively green as there were pockets of grasses and wildflowers growing, despite being drought years. They would spring up courtesy of summer storms. The rains sometimes brought torrents of water to small areas where an oasis of "green" appeared in an otherwise sunburnt landscape. I could certainly see why pioneers had thought that Mungeranie was not just a 'big ugly face' and wanted to settle there.

The Muster

6

Mungeranie was very much a working cattle station. I had to quickly adapt to the practicalities of station life. A significant part of my role as the station owner's wife was cooking. While my skills in this area were in short supply when I arrived, practice helped me improve. I also learnt from my mistakes, as had many before me.

Luckily, I never had a disaster on the scale of former station owner, Officer Ridge, who in the mid 1920's, was in camp one night, hot on the trail of a few stolen police horses. The men sat around a campfire, looking forward to the evening meal – just as Eric did on the muster – their horses packed with enough food to last three days. The cook would then arrive with stocks to replenish the mobile larder. On this night, Officer Ridge's camp cook accidentally used sheep dip instead of curry powder. All of the men became violently ill and tragically one of them, George Reece, died.

By the 1960's, there was probably more expertise in the way food was prepared and cooked than in Officer Ridge's day, although camp cooking probably had not changed that much.

I remember Eric's father, Claude, coming to Mungeranie from Nyroca Stud, on a visit. When he arrived, I was in the middle of cooking, in preparation for the men to go mustering cattle. It was always a mammoth task for spouses of station owners. Food, plates and tins were strewn all over the kitchen. I would cook up about 30 tarts – some with treacle and bread, others with dried apricots or jam. The tarts were stacked together and placed in flour bags. These went with other food into saddlebags that were carried by the packhorses. The men would also take four baker's tins of fruit cake, boiled meat and a full shoulder roast. There was usually enough food to feed up to 20 men on the muster camp for three days, after which the horse tailer became the camp cook.

I remember that the men liked the way my tarts kept on the journey. They never broke up. One day, I was in the camp and I tried some of my tarts. They tasted like cardboard. It turned out that I had followed the tart recipe in my school cook book to the letter, but it failed to state that self raising, rather plain flour, should be used.

Surrounding stations were represented on the muster and Eric and our stockmen would help out at other stations. All the dams had yards adjacent to them to enable calves to be branded. It was the horse tailer who placed hobble straps on the horses each night in such a way that they would not roam too far from the camp. When the men returned home from a muster, we would hear the hobble straps ringing and the whips cracking long before they appeared over the rolling vista of sand hills.

The 'fats' (fat cattle) were drafted and brought back to

the station ready to be trucked to the Marree railhead for sale. Each horse had a specific role, some were packhorses whilst others were used for specific and often difficult tasks. The broncos became expert in pulling the calves that were in the yard to the place for branding. The smartest horses were the prized camp horses which could bring out a single beast from a mob (herd) of cattle. Once you put these horses behind a cow they persisted until they got the cow cut from the rest. To the station men, their camp horses were very special. They loved and protected them to the extent that they would not allow anyone else ride them.

We had a horse yard near the homestead. At the centre was a specially built round yard, designed and crafted by Eric, to brand and castrate the calves. When we didn't have a bronco horse to pull the calves up, my job was to jump in the Toyota and tow the calf, which had a rope thrown over its neck, to the men. They would be waiting with branding irons and knives. Bits of meat, such as the young bull's testicles, were tossed aside, over the fence, where the dogs devoured them.

Eric was often away on muster. It could be for a few days or weeks. Traditionally, the mustering and droving season stretched from April to September. In the old days, droving thousands of 'fats' – prime beef on the hoof – from the rich pasturelands of Queensland, down through Birdsville and along the 514 kilometre stretch of the Track to Marree, was a sight to behold. Great herds of cattle advanced across the plains of dust with their drovers, their masked faces almost hidden behind wide brimmed hats. Eric was born to such a life and I married into that tough living environment.

I experienced a weird mixture of dread and excitement the first time Eric went away on muster for an extended period. The dread came about because of the isolation. The night was the worst of it, the dark plays tricks with your mind, so too the cries of animals – the howl of a dingo, the shriek and thud of a wildcat and an odd squeal of a bird.

Eric and I had taken to sleeping under the veranda and I continued to do so while he was away. I found some comfort with our border collie, Skipper, under the bed and my trusty .303 rifle beside me. Skipper was the dog I inherited from Nan and Jackson Oldfield. He was a magnificent black and white border collie with a lovely nature and proved to be a wonderful companion.

On one occasion, when Eric went away mustering for three weeks, I was lying on our bed under the veranda and saw lights that seemed to be in the general direction of the main gate. I was too frightened to get out of bed and investigate their source. I had the .303 rifle in my hands and Skipper by my side, but I was terrified. During the Cockatoo session on the wireless the next day, I learnt police were hunting a prison escapee. The police eventually contacted me and told me that the lights I had seen were those of the stolen car. A Yatala jail escapee had camped right on my doorstep, at Mungeranie Station's main gates. The police also told me they had decided to wait for the man to drive off. Had they tried to apprehend him that night, he might have rushed into the homestead.

Another occasion when the men were out on muster, the co-owners of Clifton Hills Station, Gwen Hughes and Bob Simpson, turned up. They were immaculately dressed in their RM Williams outfits, shining boots, neatly pressed shirts, jeans and belts with

big buckles. They stepped from their Mercedes limousine and sat down for afternoon tea. Their immediate question, "Val, why aren't our cows calving? We don't seem to be getting any calves." Without the cows calving every season, replenishing stock, a station lost money and eventually the stock numbers dwindled until the entire herd was lost. It was not such a mystery. Many helped themselves to another man's beef. Bill 'Swampy' Marsh, in his celebrated book of RFDS doctor yarns, records a youngster talking on the School of the Air about his Father.

"Dad's not here today. He'll be back tomorra."

"Oh, where'd he go?"

"He's just gone over to get a 'killer'".

"A 'killer', of course, is an animal you kill for your own meat. And, I mean, it's a well-known rural joke that if you ever wanted to find out what your own beef tasted like, you just went over to your neighbour's place and had dinner there. So here's this kid broadcasting to everyone in the Kimberley that his dad wouldn't be back until tomorrow because he was on his way over to the cattle station next door to knock off one of his neighbour's cattle. So the kids were always dobbing you in, in one way or the other, and the RFDS provided the radio."

The above is an excerpt from *More Great Australian Flying Doctor Stories* by Bill 'Swampy' Marsh (pp67-68) ABC Books, Sydney, 2007.

I guess, at times, station owners found a few head of cattle missing, but they accepted some losses. It was the way it was, and unless it was out-and-out cattle rustling of lots of head of cattle, which was a 'no-no' anywhere in the Outback, no-one really took exception. The odd 'killer' was an accepted practice.

But I did feel for Gwen and Bob as the practice was obviously becoming a problem.

Keeping track of cattle generally, was a problem. As there were no fences on Mungeranie Station, it was difficult. A man named Peckanic ran the General Store in Oodnadatta. A pilot, with his own private Cessna aircraft, Peckanic flew groceries to far-flung outstations. He also helped Eric take a bird's eye view of his cattle. Once I got in his plane with Eric to take a look at our cattle wandering about Coopers Creek. As there was no back seat, I sat, uncomfortably, on the floor. I was pregnant with my daughter Susan, and quickly became nauseous. Worse was that Peckanic would say, "we're going upstairs" and the aircraft would corkscrew its way straight up, and then hover momentarily before screaming downwards in a seeming death dive. God, I was glad to survive that ordeal. We gave Peckanic a load of freshly killed meat to pay for his services.

Weeks later, during a few days of continuous heavy rain, Peckanic radioed in that he was flying over to Mungeranie. I told him that I didn't think I could find a place for him to land. He said, "Well, Val, I'm past the point of no return. I'll run out of fuel. I have to land at your place." Frantically, I drove the Toyota about the perimeter of the homestead. The main road was our only bet. It was made of white clay and although hard, was quite porous. There was a thin covering of shale on top, but the road seemed firm. Peckanic's landing was pretty hectic. He pulled the aircraft up only a metre or so from a huge dip filled with enough water to completely engulf the Cessna.

Most times when Eric went away, I lost track of the days. To keep my sanity, I placed a list of 'things to do' on the

refrigerator door. I set myself a specific task for each day. It might be something like painting a bread tin, cleaning a room, or tidying a cupboard. It was a matter of keeping busy, but the days dragged and the nights were frightening. Nowadays, there is far better communication and I am sure one would not feel quite so lonely and vulnerable.

Regardless of Eric being on muster, each day seemed to meld into one. There was no working week on the Track – no Monday to Friday, followed by a leisurely weekend. Every day was a work day. There was no rest for anyone, especially the women of the Outback. The chance to chat with the others over the wireless was on hand daily, but the sad thing was we had little to say from one day to the next. It was clear that the isolation and loneliness had a huge psychological impact on all of us. I guess these feelings manifested themselves differently for individual women – but impact, it most certainly did. I think my sense of humour held me in good stead and helped me cope with some difficult times.

Although interspersed with long uneventful periods, there were unexpected happenings, like the time during the drought and in a dust storm, when a single engine plane landed right next to the homestead. The pilot jumped out and rushed to the house. By the time he reached our door he was covered in dust and yelling, "Where am I? Show me a map. I'm lost!"

Bores were good markers for many a traveller on Mungeranie and other stations in the Outback. Each station along the Track had within its boundary, or within easy reach, a government bore, sunk into the Great Artesian Basin in the 1880's. They were 40 kilometres apart to ensure cattle had access

to water when they needed it. Perhaps the government workers responsible took the lead of Roman times, when soldiers in full armour marched an average of 30 kilometres in a day. Cattle on the hoof on the Track could walk 10 kilometres further than a Roman soldier in full battle dress. In 1890, a government bore was sunk at Lake Harry. Dulkaninna bore was dug in 1898 and the bore at Mungeranie, sunk to a depth of 1027 metres, was completed in 1900.

I was to learn through bitter experience that bores alone were not enough to nourish the land as drought continued its life-sapping creep and that musters would dwindle to pitiful events until they became non-events as most of our cattle died.

The Good Life

7

Our lifeline to civilisation was Tom Kruse. His arrival was always exciting, not only because he was a character and gentleman, but because he would bring news, mail and newspapers – usually the Sunday Mail. Despite my relatively young age and the laid back sort of lifestyle we had, he always called me Mrs Oldfield. After he left, we would rush to sort his deliveries and settle down with 'a cuppa' to enjoy it.

Just before my 21st birthday, Tom's visit was especially welcome, with letters and cards arriving. A 21st birthday was quite an event – a coming of age – in those days. I had no idea what it would be like to reach such a milestone living in such an isolated part of the world. Before the big day, Eric and I went to visit Cath and Bryan Oldfield at Etadinna Station. Aunty Ida had recently left to live in Adelaide. Cath and I shared a magnum of champagne to celebrate my birthday. We sure celebrated! I remember Cath passing out behind the lounge. We had to return to Mungeranie to load cattle the next morning and all the way back during the drive home, I told Eric how much I wanted to become a mother. I was drunk, but the want

was real. I was so lonely that I had made pets of chickens and budgerigars. I think, because of the isolation and the loneliness on the Track, I simply had to mother something.

As soon as we got home, Eric said, "C'mon Val, for God's sake, get up to the bedroom." I am sure that was the time Susan was conceived. Up until then, Eric believed I was too young to have children and I know now that he was right. I didn't have a clue about raising children or how to handle a baby. I was the youngest in my family and naïve in many ways.

Soon after, we celebrated my 21st birthday party. It struck home how I missed my family and friends. To celebrate, people arrived from the various cattle stations along the Track and Marree. Many guests stayed overnight. The festivities were a Godsend, but I yearned for my friends.

When our first born, Susan, arrived on August 9, 1961, congratulatory telegrams were read over the RFDS wireless, as they were when the second of our three children, Kenneth, was born on January 10, 1963. Before Susan was in my arms, I knew nothing of the practicalities of motherhood and went to Semaphore to stay with my Mother for a couple of weeks to learn the ropes, between a nurse and my Mother's advice, I learnt enough to get me started. Returning to Mungeranie, I had to weigh Susan once a week. Providing she gained weight, I knew all was well. We used a pair of old scales and placed Susan in the silver coloured tin tray at one end and counter-balanced the scales with lead weights at the other. Everyone, including staff, were invited for the occasion and we all gathered around the table ready to catch Susan should she fall. Her weight was proudly recorded on a chart and displayed on our kitchen wall

for all to see. It was always a happy occasion. There were no misadventures in that regard.

Not long after returning, I decided I needed help in the home, so after placing an advertisement for a housemaid-cum-companion in the newspaper, Eric and I drove to Adelaide again. A room was provided for me at the Grosvenor Hotel, on North Terrace, which always seemed to be available for rural families, such as the Oldfields, to interview candidates for positions. I was inundated with candidates who had romantic notions of living in the Outback. I interviewed a number of girls and finally settled on a young lady who was prepared to live and work on our remote station.

My first housemaid did not last long. Unfortunately, she developed a rash on her face and it swelled alarmingly. We drove her to Marree to see the doctor, but he was unable to diagnose her condition. The RFDS came to the rescue and flew the girl out while we prepared frantically for the Clifton Hills Station muster.

We had six governesses at Mungeranie while I was there. Some stayed for 12 months, others were with us for up to three years. One young governess always wore short dresses and Eric demanded that I tell the girl to put some clothes on. He could be unreasonably prudish at times and insisted that I wear a one-piece, instead of a two piece swimming costume, when we swam at the bore drain. He made 'no bones' about the fact that he did not want other men ogling me. It was, to a degree, quite understandable as men on the station were 'starved' of women, but I do believe he was maniacal about it.

The men delighted in 'initiating' any new chum, especially

if the newcomer was a housemaid, to the 'adventure' of shooting and slaughtering a bullock for meat. They would ask the girl to go for a ride in the Toyota. The girls willingly obliged as it gave them a chance to go out with the boys and see the bush and not just the confines of the Mungeranie Station homestead. They would ask my permission and I gave it with some hesitation thinking, "I don't think you going with the men is such a good idea, but go with them if you like." While on the 'adventure', a bullock was shot and its throat slit. One of our dogs, Snowy, was the first to reach the 'kill'. In fact, the little dog believed he had killed the beast. He would jump out of the Toyota and grab the dead beast by its ear, growling in triumph. The men would sit the girl in the back of the Toyota and as they cut the meat off the bullock, they tossed the slabs and chunks, which were still moving, at her. No matter how the meat arrived, the girl had to catch it. Warm blood splattered and dripped over her face, hair, arms and legs, ruining her clothes. It was the girl's job to then roll the meat in a pan of salt and put it in a wheat bag. As it was heavily salted and freshly killed, the meat moved as if it was alive and invariably the girl screamed.

Another repulsive meat experience was to eat bullock brains. Eric loved them. The brains were a sweet-tasting meat, but I didn't like the thought of cooking them. To me, the meat was still warm from death. When it hit the pan it wriggled.

Meat figured 'big' in our lives in the Outback. Fillet steak was cut from along the spine of the bullock. The brisket was kept in wheat bags during the day, to protect it from flies, and then hung from the roof of the meat-house at night. Somehow, wild cats occasionally managed to get into the meat house and

1. GETTING MEAT FOR THE TABLE
2. SUSAN RIDING THE CALVES
3. THE FLIES ARE BAD

1

2

3

4

1. SUSAN & SNOWY
2. ERIC WITH THE PIGS
3. SALLY MY FIRST CALF
4. PREGNANT AND THEY'R HUNGRY
5. RITA & KEN
6. I'M IN GOOD HANDS 'GRETNA GREEN' GYMKARNA MARREE
7. MY FAMILY

1. FROM LEFT SUSAN, KEN, MUM, ERIC & MISS ELLY
2. PUNT ACROSS COOPERS CREEK
3. FAMILY 4

gnawed at the dangling meat. No one was unduly worried about it. The men simply cut off the affected part and we cooked and ate the remaining meat.

Because of the isolation, we made our own fun – swimming in a rough pool cut into the side of the bore drain, playing cards and enjoying our animals. How great that shallow pool was – to get into the cool water and splash about. After all, there was nothing else there.

My cousin, Joan, was a 'Godsend' for me. We would take turns in visiting each other, one week (or so), I would travel to Kalamurina Station, the next visit she would come to Mungeranie. We would dress our children and ourselves nicely for the visit, making quite an event of it. After all, it was quite a journey in a four wheel drive taking more than an hour each way, 45 miles to Cowarie Station and another 7 miles into the Simpson Desert through sandhill country, we rarely saw anyone.

One thing we all did on the stations was collect Aboriginal artefacts. Often we would stumble across a stone grinding bowl, perhaps thousands of years old, lying on the ground or half submerged in sand. A prized find was a black stone axe head. It was not a case of simply wandering out into the country, at any given time and seeing an axe head or grinding bowl that had been lying in view for hundreds, or thousands of years. Shifting sands protected, hid and revealed these artefacts indiscriminately. Usually, it was the boys on horseback who found them. They would cover huge distances on muster and I guess the bigger the area covered, the more likely they were to come across a prized Aboriginal piece.

Uncle Clarrie Bartlett, Joan's father, certainly fired our interest and understanding of Aboriginal artefacts. He was secretary of the Aborigines Protection Board from 1953 to 1962 and became an avid collector, always on the look-out for interesting pieces on our stations. He eventually gave much of his collection to the SA Museum.

Uncle Clarrie's friend, Professor (Sir) John Cleland, who was interested in the natural vegetation on our property, was another occasional visitor and was usually accompanied by Uncle Clarrie. Prof Cleland was a pathologist, epidemiologist and ornithologist. Cleland Conservation Park in the Mount Lofty Ranges was named in his honour.I loved going out into the field with Professor Cleland and Uncle Clarrie. I recall asking Professor Cleland, "Oh, why are you collecting those old weeds?" I immediately received mild admonishment from Uncle Clarrie.

Professor Cleland was always intrigued by black stone axe 'finds' because there was not any black stone around Mungeranie, or in hundreds of kilometres in any direction. Obviously, the nomadic Aboriginals had brought their weapons with them.

Another visitor who I enjoyed chatting with over morning tea at Mungeranie, was the wife of an Adelaide Children's Hospital Professor. She arrived with Tom Kruse in the mail truck. She was new to the Outback and did not know that she was required to carry a swag and food on the trip. Tom gave her a blanket and treated her to a special bush gourmet meal. For a lunchtime snack along the way, he stopped the vehicle, brought a loaf of bread out from under the driver's seat and cut two slices with a hacksaw blade. He then found a screwdriver, his 'knife', for the all-important task of opening a tin of plum jam

and spread it on the bread. Tom was a master of improvisation. To survive driving in drought and flood and get his heavily laden truck over the endless sand hills, he needed all his bush cunning and mechanical skills.

However, visitors were few and far between. Fortunately, the children kept me busy. Susan started walking at nine and a half months and was such a character, although she had some strange tastes – literally. One Easter, Mum sent her a little basket of lollies and was delighted to see that Susan still had them when she came to visit. Mum spied them on the verandah, attracting ants, much to Susan's delight. "Yes Mum, watch," I said. Along came a bull ant and Susan stamped her little foot on it. She then stooped down, picked it up and ate the ant. Occasionally, one would bite her and she would back off for a while but then she would go back on the hunt.

When the isolation started to 'get to me', I made myself very busy with cooking, keeping the books and generally administering the business and domestic side of our lives. About the time Kenneth was born, Eric's nephew, Phillip Oldfield, came to live with us. He must have been about 15 years old. A general worker, drover, jackaroo and stockman, Phillip had been living with his father, Bland, and his brother, Lyle, in a caravan at Mungeranie. Phillip was a wonderful young man. He loved Mungeranie Station and Eric and I were like parents to him. However, Phillip also recognised that Mungeranie was an isolated place for a young woman who had been raised at Semaphore with friends and family around.

Not long after Phillip came to live with us, rodeo rider Dick White, of Kapunda, turned up. Unbeknown to him, I was

watching Dick jump up on to a baldy faced bay horse with four white legs. The horse was very flighty and the instant Dick got aboard he was thrown into the dust. He dusted himself off and came into the house. He sat down and held a mug of tea in both hands. He was pretty laid back and nonchalant and didn't mention being thrown by the baldy faced bay horse. I kept a straight face and asked, "Oh, Dick how'd you go with the horses? What did you think of the baldy faced bay horse... I ride him all the time". Dick did not respond.

When we first arrived at Mungeranie Station, there were hundreds of wild horses on the property and Dick helped take 2000 brumbies away. He was with a team of brumby runners; a fabulous horseman, who could break and train them as well as anyone. They had a team of men on motorbikes and some Aboriginal drovers riding quiet horses. They would round the brumbies up and put them in the middle of the quiet horses, which were known as 'coaches'. It was heartbreaking because often the brumbies would have a foal and while the brumbies were trucked off to market, soon to become pet food, the foals would disappear from the yards. Inevitably they were shot. One big brumby stallion kicked out at Eric as he drove the Toyota and somehow the vehicle rolled. Eric and our little white dog, Snowy, climbed to safety out of a front door window, shaken but unhurt.

For all its isolation and long lonely weeks, Mungeranie was an extraordinary place, where extraordinary people at times gathered and extraordinary things seem to happen.

Animal Farm

8

Early on at Mungeranie Station, I began to look after stray calves. The first one I had was named Sally. She scoured (excreting a watery fluid) and struggled, but survived. Then she took a liking to the clothes on the line and would reach up and devour anything within reach. She chewed the ends of Eric's RM Williams' shirts and my nylon stockings disappeared down her throat. I would patch Eric's shirts up with old bits of my floral patterned dresses and different coloured materials and he copped a spray from the stockmen in camp – polka dot or red striped patched shirt tails would have given the men a few laughs.

The poddy (motherless) calves were my babies and I looked after them, often thirty at a time. They were born along the track on the muster drives and during the long haul to market. Herds were often culled. Cattle station owners were always looking for a stronger, better breed of cattle and the new calves were seen by the drovers as nuisance value. Their mothers could travel much faster without their calves, so the men knocked them on the head with a stirrup iron and left them dead on the track. I saved as many as was possible.

Sometimes, I would save a calf by bringing it home with me in the front seat of our car. I would exchange jewellery I made with a stockman to give me a few calves. Eric could see my determination and eventually he built me a special enclosure for my poddy calves.

Denkavit, an enriched powdered milk which we bought in 40kg bags, was used to feed the calves. A bag would sustain a calf for the six weeks it needed to grow before it could be turned out to pasture. The feeding barrel, with tubes or 'teats', was called a 'Calfateria', allowing up to eight calves to feed at a time. I also gave the calves sulphabenazine tablets, which were past their used-by-date and unsuitable for human consumption. This medicine helped prevent the calves scouring and proved a lifesaver for many of them. After about six weeks, I turned them out to graze near the bore drain, where there was always green feed and plenty of room to wander. I was each calf's mother and protector and I worried and fussed over them. At first, the dingoes would bite them and I lost a number to dingoes. They never killed the calves outright, but the dingo bites invariably became infected and ultimately fly blown. When the calves were badly infested with maggots, their legs made a horrible rattling noise as they walked. We could literally see tears rolling down their faces. It was if they knew they were doomed. When a calf was beyond help and in dreadful pain, I knew I had to put it out of its misery. Usually, I just couldn't do it and if there was a stockman or a tourist about the place, I asked them to do the job.

One day, along came an old drover, Bill Gwydir, who immediately identified my problem and suggested that I

attach a sheep bell on every third calf. This worked a treat, keeping the dingoes at bay. Bill was a great character. He first came down the Track with Martin Costello in 1936. The pair drove 600 Mount Leonard bullocks from Birdsville to the Marree rail head and they repeated the trip later that year. In 1937, Bill went to Glengyle as head stockman and stayed for four years. Bill drove his last mob of cattle down the Track in 1968. The people in the area best remember Bill as the drover who, having been caught on the wrong side of the Coopers Creek, which had flooded the Track for the first time since 1919, had to swim his mob across the swollen waters.

My lasting memory of Bill was when he stood at the gate of the special enclosure Eric built for my poddy calves, took out his glass eye, placed it on top of the fence post and told the Aboriginals before he left for Marree, "Now behave… you'd better work, my eye is on you." Bill had lost his eye one day when he was hammering a steel dropper into hard ground. A heavy blow of the hammer knocked a lump of steel off the top of the dropper and it flew like shrapnel, striking Bill flush in the face, knocking out his left eye.

Old Bill and I became good friends. Once he came down the Track with a mob of cattle and the Dalgety buyers were on hand. Bill declared that he had picked up one of my poddy calves in his mob. He said, "I just rattled the bucket and he came straight up".

Bill and the buyers knew what had happened as Bill had altered the brand and the earmark long before the run. But the buyers kept bidding up and I finished up collecting a handsome cheque for the big beast.

NO BEATING ABOUT THE BUSH

Drover Tiger Smith, a good mate of Bill Gwydir's, dedicated this poem to his friend:

> In high-heel boots and Stetson hat
> Five feet ten he stands
> Of sinew, bone and whipcord
> The tough Australian man
>
> Girls know him from the Bluff to Marree
> He's been droving there for years
> And for this handsome Stockman
> They have shed some tears
>
> He brought a mob from the Alice
> And said to old man Kemp
> We'll make a good delivery
> Or die in the attempt!
>
> We travelled down the Hamilton
> We reached Macumba Creek
> The wingman swung the leaders
> Poor creatures they were weak
>
> Then one night around the fire
> When the Stockamn heard Bill say,
> "Travellling's pretty tough lads,
> A few old crows are done."
>
> But the night we reach the river
> Then there's worse to come
> We've quicksand from there on
> That wil drag a beast out of sight
>
> But obstacles were made to cross
> I knew we're winning the fight
> For now we reach the river
> Risking our lives to save
> As only a Stockman knows how

ANIMAL FARM

But it came for Bill to deliver
He steadied them down on the drain
Jim Oldfield said, "Was it worth it, Bill?"
He said, "Sure, I'll do it again."

So ever if you are in Marree
This hard-riding drover you may see
Just make yourself known by saying
"Come and have a drink with me."

Then he'll relate some yarns
Of his life upon the Track
Or how he broke some outlaw
Into a lady's hack

He said when he was younger
And when he got his seat
The horse that he was mounted
Was just about cooked meat

A bucking horse is play to him
He's ridden all the wild ones
And together those ribs tails make it
The bigger it is to smile

But now Bill Gwydir's married
Top a pretty girl you see
With his droving days now over
A son that mounts upon his knee

For there his rough riding days are over
It's no fault of his own
For it's his responsibility
To look after those at home

© Tiger Smith, who rode alongside Bill Gwydir for eight years

Eric was away the day some of my hand-reared poddy calves ventured into a lucerne patch, then foraged into bags of wheat for a feed. They loved cereal and gorged themselves to the extent that they blew up like balloons. What to do? To me, these calves looked as though they were about to explode. I got onto the Cockatoo session on the radio and talked with a variety of people, including Aunty Ida, about the problem. I was advised to get a length of pipe and sharpen it. The intention was to insert the sharp end into the calf's abdomen, effectively penetrating the animal's stomach. This would be able to release the gas built up in the calf's stomach.

I got hold of a pipe. It must have been at least an inch in diameter and I went to the workshop to sharpen the end so I could stick it in the calf's stomach, release the gas and all would be well in the world... or so I thought. Just as I was about to bring the sharpened pipe from the vice, a traveller waltzed into the garage and asked, "What's that thing for?" I explained and he continued, "Well, I wouldn't shove that into a calf's guts. You'll kill it." He was, of course, dead right. It seemed I needed a much smaller pipe, at least pencil thin. Without any help from me, they all survived. Had I used that thick, sharpened pipe, I think I might have had a whole bunch of dead animals on my hands.

The poddy calves became my pride and joy. We had to watch that a strap we placed around a calf's neck was not too tight because there was a danger the calf would choke on a tight rein, once it grew. The calves loved to walk and they wandered for kilometres. Eric was brilliant in tracking them on horseback. My great stockman would always bring

them home. My herd grew and sometimes one of the heifers produced a calf. Eric would get almost as excited at the event as me. Sally and Sooty were my favourites. Little did I know at the time that they were to become my financial salvation. It broke my heart when I left the station and Eric trucked them all down to Adelaide where they eventually ended up at the meat market.

For a time at Mungeranie, we also had pigs. Our pigsty, an old run-down building, was probably the former police station where policeman Jack Ridge was based before he was ordered to close the place in 1928. Eric's sister, Laurie, sent down a pregnant sow from Pandie Pandie Station. The sow had a bunch of piglets and as soon as she had nursed her family, she became very mobile and tended to forage a lot more. At the time, I was happy with the way my watermelons were coming along in a little plot next door to the pigsty, separated by a two metre high corrugated iron fence. One day, the sow somehow managed to clamber over the fence and devour every last one of my watermelons before returning to the pigsty. Another time, Eric was the successful bidder for a piglet sold at auction to raise money for the RFDS during the Marree Races. Eric and I were on opposite side of the hall. He kept putting his hand up in the bidding war and I was trying to alert him to the fact that I was on the other side of the hall. We took our very expensive little boar home and named him Cecil. He grew into an enormous pig.

Having never owned a pig, we did not know how to kill it. Uncle Doug Scobie told Eric to, "get hold of a pick handle, belt it clean between the eyes and slit its throat and you'll be

right." Eric took a sledgehammer down to the pigsty, but that didn't work. He returned to the house, grabbed the .303 rifle and ended Cecil's agony in an instant. They took the pig to the bore drain and used the hot water there to help soften the boar's hair to make the job of skinning the beast a little easier. After that, there was this huge boar's head sitting in the refrigerator. It had a nasty bump of its head, courtesy of Eric's attempt to kill it with the sledgehammer, plus, of all things, a feeding pellet on the top its tongue, lolling out of its mouth. Cousin Joan (Dunn) gave me a recipe so I could cook a type of brawn out of the pig's head, but it was awful and I gave it to Bill Gwyder, who reckoned the brawn made an excellent curry.

When the season was right, we had mouse plagues and one year, in the mid-1960's, we experienced a rat plague. God, I remember trying to kill one of them. It was in a trap and I picked up a big stone. I would turn my back on the creature and drop the stone from behind my back. I simply couldn't look at it while I was trying to kill it. Eventually Snowy, our brave little dog, killed it. Truth is, I couldn't bring myself to kill anything. There are short and long tailed hopping mice on the Track and five species of rats, including the True Rat, the Greater Long-Eared Rat, Little Forest Eptesicus and the Lesser Stick-Nest Rat. There is, of course, the Desert Rat kangaroo too. I think the type of rat that invaded the land in the mid-1960's was the True Rat. It is a rare sight to see these rodents on the open plain as they are usually shy creatures, habitating damp areas such as bore drains or natural springs. However, after a prolonged downpour – a rare event in the

Outback – True Rat numbers increased astronomically and the rats spread out over sand hills and the gibber country. The rats moved across the country and seemingly dug holes and bred as they crossed the plain in their hundreds of thousands. During the rat plague, a pilot set down on our rough air strip at Mungeranie, but when the plane taxied to a halt, neither the pilot or passenger would get out for the rats, in their thousands, formed a carpet around the aircraft. We had to rush over to the plane and assure the pilot and passenger that it was okay to come over to the homestead.

Mice plagues were also common after rain. They got into cupboards, wardrobes, in the stuffing of lounge chairs – everywhere. The stench left by their urine was disgusting. There were so many mice scuttling about that you didn't need to set baits in the traps because they swarmed in their thousands and ran into traps, or fell into buckets of water and drowned. This was a numbers game and the rodents usually won hands down, however when rodent numbers decreased significantly, it usually meant no rain and impending drought.

We also had a few plagues that delighted us in some respects, one was a plague of green budgerigars. The swirls of brightly coloured birds against the blue Australian sky brightened the dullest day. With the colour and the bright chirping of the birds, the children were in their element. When they went out with their Father to cut wood there were so many budgies about that the babies fell from the nest as Eric used his axe. The children returned to the homestead with their pockets bulging with baby budgies. At first, I didn't know how to keep the little birds alive, but through trial and error, I

happened across hot porridge. That did the trick. We had a big bag of rolled oats in the store. I cooked up the porridge and the birds gulped it down as if there was no tomorrow.

At one stage, we had dozens of budgies in the house, in various stages of development. Those which could fly flapped about the kitchen while others sat and waited for their tucker. Eventually, we had more than sixty budgies and I had an aviary made for them. While confined to the cage, the heat sapped their energy and I thought I would do them a good turn and let them loose in the wild. I later realised I did the wrong thing as birds raised in captivity rarely make it in the wild.

I am sure our pet galah Pedro thought he was the boss of all the animals at Mungeranie, threatening other animals out of the way of food, much of which was meat, put out for them, until he had had his fill. The diet may have been why Pedro lost a lot of his feathers. Often, when we went to the swimming hole at the bore drain, we would take Pedro with us. He sat up on a branch in a tree, observing us from above. When we were about to leave, we would whistle and he would be out of that tree in a flash and into the Toyota.

One day Pedro laid an egg and his name was immediately changed to Pedrina. I think he, I mean, 'she', died of a broken heart. One Christmas, it was just too hot to bring her to Adelaide in the car with us, so we left Pedrina behind.

The station life was not only hazardous to us, but to our animals as well. One of our saddest memories was finding my wonderful dog, Skipper, dead. Skipper had taken bait intended for a dingo or wild cat. Eric had put the baits in the back of a little canvas top jeep we had, ready to take them to the bore

drain. When we got there, they were gone. Skipper was dead on his chain the next morning and I buried cats for the next three weeks.

Skipper had been left at Mungeranie by the previous occupants, Nan and Jackson Oldfield. He had had the run of the place and like the chooks, enjoyed plenty of freedom. When we left the station, we would leave the fowl house door open. Skipper loved eggs and when we returned he would usually be lying on the lawn next to a dozen or so eggs. Each had a tiny hole in the shell where he had sucked the goodness out. He was on a good paddock. He got fat and his coat shone.

Disaster also struck our dog, Snowy, on one occasion. Snowy loved chasing kangaroos. He would jump out of the back of the Toyota when we were going at speeds in excess of 60 kilometres per hour, to chase a kangaroo. On one occasion after jumping, he sat in the middle of the road. Snowy had broken his leg. Eric drew his pistol and was about to shoot him. The children were crying. We ended up placing Snowy gently on a mattress in the back of the Toyota and took him home. I contacted the RFDS and received instructions about how to set a broken leg in plaster. Initially, the doctor thought Snowy was one of my children. After he realised that Snowy was in fact our dog, he gave us some instructions anyway. I set it with match sticks, cotton wool and plaster. Initially, Snowy chewed on the plaster and we put a bucket with the base cut out over his head so he couldn't reach it. After a few weeks, Snowy ignored the plaster and he was jumping off the back of the vehicle again, ever on the pursuit of kangaroos. Eventually, we cut off the plaster and after a few days rushing

about on three legs, Snowy found the courage to put his other leg to the ground. From then on, he was away. Later, the nurses from Marree came to stay and checked Snowy's leg. They said one of the bones overlapped the other a 'little bit', but because it had been a clean break, I had got the bones together 'pretty well'.

The children also delighted in our pet black swan which we called Swanny. The bird had come from my parents who had come across a family of black swans on the Birdsville Track at Lake Harry, when heading back to Adelaide from Mungeranie. They grabbed two of the cygnets and sent them up in a box with Tom Kruse, who was heading towards Mungeranie on his mail run. One of the cygnets died, but Swanny survived, growing into a big black swan that followed me and the children about the yard.

Swanny didn't fly and we swore she thought she was a human being, so I decided to teach her to fly. When feeding my calves one day, I called out to Swanny and she followed me. I ran faster and faster and then jumped into a hole that Eric had dug for a proposed swimming pool in the backyard. I must have looked a sight in my big floppy hat, boots and dress, but it did the trick. Swanny took off, soaring over my head. It was only when I popped out of the hole that I realised a group of tourists had been watching and laughing, it was worth it.

The children also had a lot of joy from our ducks, although understandably found it distressing when crows swooped to take the heads off the babies. Wobbly, our drake, became their 'golden goose', once the children came to

understand the mating process. They had been distressed by Wobbly's 'advances' towards the females. On one occasion the children rushed to the aid of a duck being drowned by Wobbly in the duck pond. To the children, he seemed to be pushing the duck under the water – a life-threatening situation. They rushed at the drake with a broom and fought him off, thus 'saving' the duck's life. The children locked Wobbly in a shed, away from the rest of the ducks and reported the incident to me. I explained that a few months after Wobbly hopped onto the duck's back there would be another lot of ducklings arriving at the pond. They later learned the Marree butcher would pay them $1.50 per duck. It didn't take them long to work out that Wobbly's antics in the pond would soon mean more money for them. When they saw the drake 'on the job', Susan and Kenneth would rush into the house and yell, "Mum, Dad, Wobbly's injecting the duck! There's a whole lot more $1.50's on the way. "

As the days wore on, drought was upon us again and along with the big dry, came the dust and the inevitable swarms of flies. I busied myself, looking after my poddy calves, which became all the more difficult in the big dry. Anyone who has lived through drought in the Outback will tell you that it is a phenomenon of nature that eats away at you. You virtually live in dust. We would have an average of three dust storms a day. Dust inundated the place. We tried opening all the doors so the dust would come in one entrance and disappear out the other end, but to no avail. We were stuck with living in dust.

Flies were the bane of our existence. All the children wore fly nets. Flies have been known to eat the eyes out of

horses, but they worked their own strategy when the flies swarmed. The horses stood tail to head, using their tails as fly swats. Some also wore specially made leather fly veils when they were being ridden, so that when they shook their heads, the flies could not get to their eyes.

Worst of all were the sand flies, which didn't bite you but urinated on the skin, creating an itchy bump. We would rub raw onion onto the bites as it soothed the affected skin. Imagine the smell as we all sat down to dinner covered in onion juice.

There was a corrugated iron veranda right around the house and it was a haven for spiders, including the dangerous Red Back. When the roof became very hot, they would descend on thread of web and sometimes land on you. This created a dangerous situation and the only solution was to spray them with poison. I ended up with a 12 centimetre high pile of all manner of insects, in addition to the spiders. Centipedes and scorpions also often lurked around the veranda and inside the house. We killed a few, but there were always more.

Possibly the most frightening of our unwelcome household 'visitors' were the snakes. On returning from Adelaide on one occasion, we found a mother and its nest of young snakes in the children's school room. It was the odd stray snake we found, or didn't find, in the house that was most worrying. With our house lights often growing dimmer during the night, we invariably relied on using a torch when we got out of bed. I never knew what was lurking under my feet, or in the shadows. On a few occasions, when a snake had been sighted in the house and we did not know where it

had gone, we sprinkled talcum powder on the floor, hoping that the snake would cross through it, leaving tracks. It didn't always work.

While it might seem that animals controlled our lives, there was nothing unusual about our experiences. Living remotely, I grew to realise, even more than I already did, how animals could enrich one's life and how intricately entwined their existences were with ours. Life would have been unbearably dull without them.

Rita

Rita, an Aboriginal and a good woman, was one of my best workers. She was fastidious and meticulous in her care of our veranda, which she cleaned daily and kept in a spotless condition. She lived in the men's quarters with her man Lachy, a stockman, whose forebears were a mix of Chinese and Afghan. While Aboriginal workers chose to live in relatively primitive conditions on other stations along the Track, I insisted that our indigenous staff lived in decent quarters.

The children loved Rita and Lachy and they became great friends. Susan and Kenneth were like little puppies following them about. Rita would take them to the sand hills and show them how to catch rabbits and lizards. She loved the children and once, during a rabbit plague, took Kenneth out on a hunt. Armed with a long wooden stick, Rita went to a sand hill and sat by a rabbit warren where she poked a stick down the hole. Should she discover fur at the end of the stick, she knew 'they' were at home. That evening, Rita came home with Kenneth, no rabbits to show for their efforts. Rita was mumbling away, "I don't know about that boy," shaking her

head. Rita had stationed two-year-old Kenneth at the mouth of the rabbit burrow, having told him to catch anything that flew out. Meantime, Rita dug away a few feet down to a point she thought was the bottom of the burrow. "Missus, I dug all day and at last a rabbit came out, but Kenneth missed it," she wailed. I was glad Kenneth was too late to snare the rabbit because a cornered wild rabbit would scratch and claw like mad.

Every night was special at Mungeranie Homestead. Everyone showered and dressed for dinner, held mid-evening. The women combed their hair, put on make-up and dressed neatly, while the men dressed in their RM Williams trousers, with white shirts and polished boots. Rita was very protective of the house, which she kept clean as a new pin. She stood, arms folded, giving the 'evil eye' to any man wearing his boots who dared to walk on her highly polished veranda floor.

Rita did not usually complain about anything. An exception was the time she was in pain with one of her back teeth. She desperately needed to see a dentist. There seemed to be nothing we could do to ease her pain. We tried our grandmother's solution of oil of cloves, but nothing worked for her. One day, Rita turned up all smiles… no toothache. I quizzed her and she confessed the pain had become so unbearable she had taken a pair of pliers and with one enormous yank, extracted the decayed tooth.

Rita was such a character, yet she had strange ways. Over the years she had been so good to our family that I decided to reward her by measuring and buying her new clothes – a dress, underwear, jewellery and slippers. Rita had a shower and put on her new things. At that time, the boys were breaking in

colts in the house yard and we had a number of Aboriginal stockmen, along with Jimmy Dunn, staying at Mungeranie. Jimmy Dunn walked past her and said he couldn't believe his nose as Rita had doused herself with a full bottle of perfume. That night, the men 'partied' and the next morning Rita's man, Lachy, was wearing her beads around his hat. One of her brooches adorned another man's hat. Her clothes were soiled. She stood in her dress and slippers and handed me her bra, which was filthy and said "Missus, you have these. No fit me. They hurt."

To me, the greatest attraction to life on the Track, were the fascinating stories and superb, laid back humour. It seemed everyone had a story, especially the drovers and the stockmen. The Aboriginals always spun a good yarn too. They had, of course, plenty of practice in story telling, for indigenous Australians have been handing down oral history to their people for thousands of years. I got to know many Aboriginals at Mungeranie Station. They were vastly different to us but they knew how to survive in the intense heat and the extraordinary cold of the Track.

We learnt a great deal from Aborigines about surviving in the Outback – like finding water and identifying animal tracks. One was 'Slippery Sam', a stockman who was based at Kalamurina Station and who often helped out at Mungeranie as a track rider. As the stockmen rode around the cattle, his job, along with the other track riders, was to chase down stock which broke from the mob and bring them back to the herd. Sam had taken some provisions with him, but there was no meat at our station so we gave him a rabbit trap and told him

NO BEATING ABOUT THE BUSH

to catch his own meat. Days later, we saw him and asked, "How did you go... did you get a rabbit, Sam?" "Boss, I do better. I have a big cat in the bag," he said. Slippery Sam had caught a wild cat and he lifted the animal – its hair singed and looking half cooked and half eaten – from the hessian bag. Thousands of years of hunting and gathering gave the Aboriginals great skill and cleverness in catching prey, although their tastes were obviously quite different to the white settlers and their descendents.

The Aboriginal women could be charming, hard working and clever however I believed they could also be callous and tough towards their own kind, especially their children. I heard some horrific stories of how some Aboriginal women treated their offspring. Long before the end of World War I, a station owner and his wife were invited to witness an ancient tribal rite they called cupakety, the 'disposal' of two members of their tribe who were considered to be 'incurable' and thus would be put to death. This surely was a primitive, perhaps centuries old, form of euthanasia. A large trench had already been dug in the side of a sand hill. Logs, which had been placed in the base of the trench, were well alight. They had burned day and night. Green branches and leaves were tossed on top, causing the smoke to be trapped and the smoke to become noxious. At the foot of the sand hill sat a boy of nine or ten. He rolled his head involuntarily from side to side and his tongue protruded grotesquely from the corner of his mouth. Alongside the boy sat an old woman, who, although unable to move a limb, had been placed in a sitting position in the sand. She had suffered a severe stroke. When smoke billowed from

the trench, poisonous gas from the burning green leaves and branches created a blanket of toxic gas above where the two Aboriginals were to be interred. Tribesmen then carried the pair to the gaping hole and placed them on top of the branches. No sooner had the pair been placed in the trench, piles of green leaves were thrown in on top of them. Earth was then piled high about the opening and more logs thrown on top of the branches and leaves. No sound emanated from the trench. Perhaps the poisonous smoke immediately anaesthetised the pair. To those of European extraction, the ritual was a bizarre event, yet the unfortunate pair's death was seemingly humane. In our society, people are kept alive in the most horrendous situations. Often the dying, many who lie in excruciating pain, the like of which even huge doses of morphine cannot relieve, are kept alive by an assortment of drugs which do little other than delay the inevitable for a day or so.

Thousands of years before the Track became the Track, the Aboriginals had lived and died their way. They did not have modern medicine. They could not call up the RFDS if something went wrong in their tribe. They had to rely on umpteen tried and trusted remedies that had stood the test of time over many years.

After our third child, Martin, was born, Eric was passing through Marree and met Rita, who was not living and working at the station at the time. She asked, "Has missus had the baby yet, boss?" When she learnt that the baby had just arrived, Rita offered to go back to Mungeranie with Eric and prepare the room for Martin. Rita did a fabulous job. She had the house and the special baby room looking like a new pin.

Rita adored the new baby, as she did Susan and Kenneth. We would go down for a swim at the water hole leaving Rita to look after the baby and when we returned, she would be sitting in the same position, staring lovingly at the baby in the bassinette.

Rita looked after me so well that I decided to foster her last child, a boy. All her children had gone to foster homes. If I fostered her son, she would be able to have him with her all the time. We completed the administrative matters, signing all the relevant documents. I wanted this little boy to have a secure home, with his mother and attend school with Susan and Kenneth. All was set, the papers were signed, Rita and Lachy seemingly very happy about the arrangement. Sadly, the boy was on the station for just one week. The last I saw him, he was going down to Marree on the mail truck. Rita had him and all her cats on board. When she returned, Rita had her cats with her, but not her little boy. "Where's the little boy?" I asked Rita and she said, "Oh, missus, I leave him with aunty in Marree." That meant the boy was now with the tribe and I never saw him again. All the children and possessions belonged to everyone in the Aboriginal community. The Aboriginals probably cannot understand our ways and we have trouble in comprehending their culture.

Rita was also very superstitious. If I was planning to be absent from the Mungeranie Homestead for any length of time, Rita would come to me and say, "Missus, you take care and be back before dark, otherwise Kurdaitcha Man get me!" The Kurdaitcha Man was the tribal executioner – the name derived from the Arrente people who have inhabited

a huge part of central Australia for more than 20,000 years. Kurdaitcha Man sneaks up on his prey. He wears special feather and human hair woven slippers, perfect for stealth in the night and when Kurdaitcha Man points the bone at a victim, he or she believes they will die. In almost every recorded case they do, in fact, die. Their strong belief system makes it happen, for once Kurdaitcha Man points the bone, the victim stops eating, does not drink and while the fatal attraction stems from a deep psychological trauma, death comes from starvation and thirst.

There is a tale about Kurdaitcha Man on the Track that came about just after World War I, when an Aboriginal girl, called Esther, lay on her bed at Pandie Pandie Station. She stared at the ceiling and could only utter an intermittent moaning sound. Despite there being nothing obviously wrong with the girl, she was firmly convinced she was going to die. Another Aboriginal girl sidled up to the owner of the station and said, "Esther is going to die, " 'im fella yabba point bone alonga girl." For some reason, the girl had raised the ire of the mysterious medicine man, who had pointed the bone at her. Just as scientists today cannot fully explain the strange aeronautical flight of that ancient 'aircraft', the boomerang, modern medicine does not appear to be able to help an otherwise healthy and fit indigenous person who has had the bone pointed at them.

As Esther lay awaiting her fate, Aboriginals snuck into her room and secretly placed such nasties as centipedes and scorpions under the sheets of her bed. They were hoping to ease the girl's suffering with a quicker death, but to no avail.

The girl died and later when the station owners asked doctors to explain the 'pointing the bone' phenomenon, they were told it was simply a case of 'black magic'.

Given such deep fears and stories of Kurdaitcha Man's power among the Aboriginal people, it is not surprising that Rita was always happy when I returned to the Mungeranie Station in the evening.

Susan and Kenneth spent many hours with Rita. She taught them about the bush and basic aspects of Aboriginal culture. They loved to watch Rita and Lachy cook a goanna, or go with Rita on a rabbit hunt. She also taught them to find frogs which might be buried deep in the earth, but would magically appear when the rains came. When the big wet occurred, the frogs would be hopping about all over the place.

My children, especially Susan and Kenneth, never forgot their life at Mungeranie. Now, aged 48, Kenneth clearly recalls his early life at Mungeranie Station and certainly remembers Rita and Lachy. He bumped into Lachy at a pub in Oodnadatta years after we moved away from Mungeranie. Lachy was sitting just inside near the window and was dressed immaculately in a clean, white shirt. He was the neatest person in the pub.

The children seemed to inherently appreciate the Aboriginal people's tie with Mother Nature. I think Aboriginal author, Hyllus Maris, a Yorta Yorta woman who died at the age of 52 in 1986, portrayed the unique relationship between the Aboriginal people and Mother Nature beautifully in her poem entitled, Spiritual Song of the Aborigine.

I am a child of the Dreamtime People
Part of this Land, like the gnarled gum-tree
I am the river, softly singing
Chanting our songs on my way to the sea
My spirit is the dust-devils
Mirages, that dance on the plain
I'm the snow, the wind and the falling rain
I'm part of the rocks and the red desert earth
Red as the blood that flows in my veins
I am eagle, crow and snake that glides
Through the rain-forest that clings to the mountainside
I awakened here when the earth was new
There was emu, wombat, kangaroo
No other man of a different hue
I am this land
And this land is me
I am Australia.

<div align="right">Hyllus Maris ©</div>

It is difficult for me and many others to have real empathy with the concept but like my children, I also appreciate it. My appreciation of Rita however, goes further. I have a special place in my heart for her and I am eternally grateful to her for the companionship and her kind and caring manner with my children.

Marree

Marree, at the southern end of the Track, was a town on the very edge of danger. The sorry fate of the Page family in the Simpson Desert is testimony to this. However, Marree is perhaps mostly regarded as a hub of supplies, friendship and socialising. Its annual race day personified the latter. It was a big deal; a gala event and something to look forward to. We always turned up for the Marree Race meeting.

Gone are the days when you would get a nod and a wink from those in the know and you reckoned you were on such a sure thing. If you didn't actually bet the value of the station on a horse, you would invest a few hundred pounds. One day we got 'the nod' about a horse called Black Adam. He was said to be a 'certainty" and was backed to out-right favouritism in minutes. If you didn't have a few quid on Black Adam in race one, you were considered to be something less than the full quid.

We were enveloped in a whisper of enthusiasm for Black Adam as soon as we arrived at the Track. The horse certainly looked the part. He was an impressive big, black stallion. A 'friend' wearing a high-crowned stockman's hat and with a glint in his

eye, said to us, "You're mad if you don't back 'im". He can't lose. C'mon Val, Black Adam is a sure thing". He apparently knew that Black Adam had been doped up to the eye-balls. Unknowingly, we and our friends placed our bets. The field boasted only three horses – pretty typical of the races at Marree, giving the punter a basic one in three chance of a win.

Despite being first out the block, Black Adam wasn't really in the race at all, hobbling around the course like an old hack. He was more like a drunk on skid row than a highly tuned champion athlete on a 'high' from dope, which we later learnt takes some time to take full effect. The others soon caught up and our big bet finished three or four lengths behind.

At the start of the second race, Black Adam was jumping out of his skin and the devil ran magnificently, winning by the length of the straight. It was all too late for our little syndicate because we had lost our money on the first race. We vowed after that dreadful effort that we would never again bet our hard-earned money on the racehorse they called Black Adam. We cut our losses. Losing money on the track was a bummer but we weren't going to lose our sense of fun.

One of the greatest attractions on race day in Marree was the dance to celebrate the event. Held in the Marree Hall, I always looked forward to this annual dance, either making a special dress or sending to Adelaide for a new one. All the station women dressed to the nines. If they could not sew a stitch and fashion their own unique outfit for the occasion, they begged, borrowed and stole their way to get the perfect gown. The dance also brought the best out of the men. These tough, sunburnt outback men shook the Track dust out of their

clothes, even condescending to shower, shave and comb their hair. Their hats and spurs were left outside and their boots were polished to a splendid sheen. Tourists turned up from Adelaide, Quorn, Leigh Creek and other surrounding areas. It was rare for us not to enjoy ourselves, despite the odd scuffle, like the time an Aboriginal stockman asked me to dance and was summarily removed from the hall by Eric and his cousin, Bryan.

It may seem astonishing today but mothers left their children in the family car outside the Marree Hall, as did we. Susan and Kenneth loved the excitement of sleeping in our car while Eric and I enjoyed the entertainment in the hall. We and other parents checked on the children every hour or so. There were rarely any problems with them, or the dance, but there were quite often disturbances at the historic two-storey Marree Hotel, built in 1883 and now called the Great Northern Hotel.

Whenever the men went to Marree, the hotel was always the first port of call. When they were bored, thirsty, had a row with their wives, or just wanted fun, the men always headed for the pub. They especially loved the antics of Dirty Dot, a part-Aboriginal woman, who was a fencer; not the type of skill you associate with sabre and cutlass but the fence building kind. Dirty Dot repaired and built fences and stockyards along the Track. She dug the holes and rammed the earth and attached the wire. She was considered a good fencer, but her greatest claim to fame, in Marree, which caught on with an extraordinary mix of stockman, drovers, doggers and bar flies, was Dirty Dot's risqué dancing on the bar at Marree Hotel. It provided the men with a certain vicarious pleasure. When she took off her old and trusty frayed sandshoes and replaced them

with her only other pair, her dancing sandshoes, the action started and the bar goers went into an uproar of excitement. She would gyrate and lift her skirt up to the men's cheers. To encourage her audience, with each successive cheer Dirty Dot would lift her dress that little bit higher. She invited the blokes to play with her but Dirty Dot rarely got any takers because the boys weren't likely to do publicly what they never would have dared do in private. However, seldom did the boys walk away. They stayed in the bar to leer at Dirty Dot and drink to closing time with their mates.

The unforgiving nature of life on the Track probably explains why the bush men were so tough. If there was an argument at the pub, they sorted it out there and then. Why, for goodness sake, would we call the police when a couple of well-timed left hooks could do the trick?

When our children were toddlers during trips to the races at Marree and sometimes on our way back from a trip to Adelaide, we stayed at the hotel and set up a barricade of suitcases on the first floor so the children would not tumble down the stairs. There wasn't any air-conditioning, not even a fan in the room and the beds were hopeless. The mattresses had springs, which had long given way and when you got into bed you slid into the middle and sunk almost to the floor. Once we stayed there during a dust storm and the dust got into the room – into the luggage, the bed, everywhere. The dust was so thick on the floor the children drew pictures in it. When we drove home, we headed into the storm and upon our arrival, discovered that the force of the gritty dust had stripped our car of paint.

MARREE

Marree Hotel was always a chaotic scene. Downstairs in the hotel lobby, there was a board signifying room numbers and the number of beds in each room. Tourists would arrive, often late at night, from the train station. More often than not, a husband and wife in a room would find a total stranger occupying the spare bed in the room they had been allocated.

Eric and I didn't dine much at the Marree Hotel, but I'll never forget one occasion when we ordered leek soup in the dining room. The manageress brought along the tray laden with bowls of soup and to our astonishment, the long beads she wore around her neck trawled through the soup, dipping and bobbing like little corks in a muddy pond. No one really caused a fuss about it. That was the way it was in the bush. There didn't appear to be a skerrick of occupational health and safety practice at the hotel, for the kitchen was the chief domain of a talkative, albeit cranky, resident yellow-crested cockatoo.

We spent more time at Marree than in Birdsville. There were two general stores. With the exception of dresses, the store near the hotel had everything one could possibly want, even a coffin. There didn't seem to be anything like an undertaker in town, so if there was a death, you went to the store to buy a coffin. Burying someone in the summer months was a bit of a struggle because it was so hot the ground was baked as hard as iron by the relentless sun.

Another person who became well-known at Marree was one of the area's great characters, a truck driver and roustabout Shamus O'Brien. Shamus had no feeling in his hands, or arms. Unfortunately, there were those who sought to take advantage

of Shamus' 'condition' and encouraged him to skylark about it. Typically, he invited patrons at the Marree Hotel to throw darts at his unprotected left arm. Shamus placed his hand against the wall near the dartboard and the players all happily agreed to have a shot at the amiable Irishman. A dart hit his hand and penetrated the skin, but Shamus hardly flinched. Another day, five players threw at once. He showed no concern for his personal safety. He would just pluck the darts out and say, "C'mon 'ave another go. Aim for my thumb."

Eric and the other men often took Shamus to the first floor balcony of the Marree Hotel and dared him to jump off the balcony to the dirt roadway. They would stand on the road below the balcony and call out to Shamus, "Flap your shirt tail, Sham and you will fly." Shamus would jump off the balcony a number of times and the men thought it a great joke. Once, Shamus was even tossed off the back of a speeding Toyota tray-top.

Shamus was one of Tom Kruse's favourite characters in the bush. He said he was an amazing fellow, completely loyal, and drank too much – never pretending he was not an alcoholic. Tom said he would do anything for a mate and that he also admired his thirst for knowledge. Apparently, Shamus was a great reader, 'devouring' anything from Shakespeare to Tolstoy and was articulate, quoting from a wide range of texts. The men would gather around Shamus at a bar. It might be at a hotel in Birdsville, Lyndhurst or Marree and Shamus would hold the floor. If you wanted to know a date in history he knew it, the hour of the day in 1940 when the Battle of Britain began; Winston Churchill's birthday; the day and the year the RFDS

began in Australia; or the month and year of the sinking of the HMAS Sydney off the coast of Western Australia.

Not only was Shamus a great reader and a personable and knowledgeable speaker on a variety of subjects and events, he would often recite an old poem in tribute to the truck drivers of the Track. It was verse that no one knew the origins of – not even Tom Kruse. But Shamus knew it off by heart and like many a bush yarn, he told with passion. No doubt such poems are fading into history with the passing of Shamus.

> Swing to the cabin and press the switch
> And give the diesel the gun
> It's three hundred miles up the Birdsville Track
> And we've got to be there with the sun
>
> Whether they wait for bottles or bricks
> Spuds or steel or lime
> Never doubt that a truckie's skill
> Will get you there on time
>
> We cop the blame for broken roads
> We're shadowed and chased by cops
> But we ride again through the quiet towns
> Where we gulp down pies and chops
>
> We're for this and taxed for that
> And cursed as a highway blight
> But a thousand tons of goods will roll
> Three hundred miles tonight

MARREE

Somewhere tonight in the lonely dark
A truckie is bathed in sweat
Changing a wheel or an axle stub
Or swapping a dust-choked jet

We've wives and kids of our own it's true
Though sailors see more of theirs
We live in a cab 'neath shuddering roof
On a floor full of pedals and gears

Dust in our mouths, oil in our veins
And grease in our wretched souls
We roll to the west, north, east and south
Glued to a diesel's controls

Cars for Sydney, beer for Bourke
And washing machines for Nhill
Cement for Gympie and Charters Towers
And boots for Broken Hill

Whyalla is stuck for a load of tiles
Port Pirie is out of nails
There's a red dust cloud o'er the Condoo trail
Where a truckie goes with the rails

Two hours to dawn on a mountain road
With a roar that wakes the night
An eighteen wheeler thunders on
Its load lashed trim and tight

With twenty tons of water pipe
On an eight by forty deck
The man at the wheel of this great rig
Is risking his flamin' neck

For if the booster should fail on the winding slope
Or the offside wheel should blow
She would swipe the cabin and overturn
Into the valley below

But maybe with skill and good luck she wont
So give the diesel the gun
It's three hundred miles up the Birdsville Track
And my word we'll be there with the sun.

<div align="right">Anonymous</div>

In the mid-1950's, Shamus was stranded in Outback Lyndhurst. His truck had broken down and the radio was broken. He had no food and little water, but he knew a search party would be called because he was never late with a truckload. The RFDS spotted Shamus' head sticking out of a dry dam. Shamus had scooped out a hole at the bottom of the dam and had buried himself to the neck. The covering of sand proved a life-saving blanket. Shamus was found in a remarkably good condition and survived, but ultimately died tragically. In mid-1965, he had been riding high on a load of superphosphate. He sat at the top of the load on a trailer, usually a position of safety, however the driver hit the brakes suddenly. Shamus lost his grip on the side

rail of the trailer and fell headlong between the back of the truck and the front of the trailer. Shamus O'Brien was dead, but his legend lives on.

Another well-known character who frequented the Marree pub was Tommy Singer who was known as one of the best stockmen in the Outback and who worked for us at Mungeranie. One day at our station, he asked me if I had any dried apricots. I assumed he was about to go on a muster. "Yes, Tommy," I said, "But they are so old they have all gone black." "Oh that's great, Val," Tommy said, his face bursting into a smile. But Tommy had another idea. He wanted to pull the wool over the eyes of the local police. A bounty was paid for wild pig snouts and when dried apricots had gone black and sour, they looked just like wild pig snouts. To fool the police, Tommy would place a few pig snouts in to the bag of dried apricots and gave the bag a good shake. In a few days, the entire contents were decidedly foul smelling. The police turned up and dropped the contents of the bag onto the ground. Holding their noses, they counted the individual pieces, poking them with a stick. They then handed Tommy the cash. "Well, I was smarter than those Marree coppers," he laughed, flicking through the notes after they left.

Apart from enjoying the characters that frequented Marree, we also made our own fun. One time there, I was privileged to ride Eric's favourite camp horse in a race against a group of Aboriginal women riders. I didn't get my feet properly in the stirrups and was half out of the saddle when the starter dropped the handkerchief to signal the start of the race. However, I won the race, still half out of the saddle. They were very smart horses. When you rode them, you just had to hang on tight. It was the

same with the flag and barrel races at Marree. These smart horses would bend low at the knee to help them negotiate their way around the barrels.

I also knew and befriended a number of people, who were not born to Marree or the Outback. Among them were the two nursing sisters at Marree. They had nursed in Alaska. Imagine the girls working in a land of snow and ice, then moving to the wide, brown land of the 'never never'. They were excellent nurses. Each week they set aside three days of specialisation at the hospital. They dealt with sore eyes, where flies had laid eggs in the corner of youngsters' eyes, head lice and venereal disease. VD was rife among the Aboriginal population. No doubt living and sleeping together in groups of 15-20 did not help.

It was the Marree nurses who had to deal with a decayed tooth of a station owner and stockman, Ernie Giles. Righting the tooth was one of two pressing matters facing Ernie when he turned up in Marree. The other was to attend the Marree Race Meeting.

The tooth was badly decayed and needed to be pulled. He found himself at Marree Hospital and the two nursing sisters, Margaret Harley and Lou Walklate, sorted him out. They told him to buy a bottle of whisky, drink the contents and return for them to ease his pain. When he returned to the hospital, the two girls went into action. Both were big-boned lasses and one of them sat on Ernie, while the other, in one powerful wrenching movement, ripped the tooth from his head.

Their efficiency and practicality was evident the day I went to the rudimentary nurses' quarters adjacent to Marree Hospital to help set a table for the nurses. As I began setting the table

with cutlery, butter and condiments, one of the nurses said to me, "Val, thank you for your help here, but whatever you do, don't touch the shoe box in the fridge." To my horror, I later learnt that there was a dead baby in the shoe box. At that time, the hospital did not have the luxury of a morgue. I couldn't believe that a dead baby could be in the refrigerator, next to butter and other foodstuffs. However, those two nursing sisters were magnificently practical.

Such stories really set the bush telegraph going, as did an ultimately deeply tragic story which started to unfold during one of our daily cockatoo wireless sessions. While dealing with routine medical issues, a nursing sister at Marree Hospital came on the air and told the doctor that a woman who had suffered great mental and physical torture from her violent husband had finally snapped and had broken her abusive husband's leg with a crowbar. In a surprising moment, the doctor blurted, "Oh, good on her". I thought it was a strange thing for a doctor to say. I was to learn later just why this woman hated her husband so much and why the RFDS doctor said something that he probably regretted.

It was 1966 and a tragic year for Australia. On January 25th the Beaumont children disappeared from Glenelg Beach. Jane, nine, Arna, seven and Grant Beaumont, four, simply disappeared, assumed abducted, causing grief to those who loved them and ripping innocence from an era known for trust. Less than three months later, those who lived in the busy Outback railway town of Marree were given the shock of their lives.

Marree Police Constable, Grant Redden, had been on duty when local resident, Vera Larkin, walked into the police station,

handed him a necklace and asked, "Would you please give this to my daughter?" Constable Redden's wife, Alison, later said, "Earlier on that same day, about lunchtime, Charlie and Joylene Larkin came to our house looking for their mother.

They had come home from school for lunch and they couldn't find their mother. Grant (Constable Redden) went looking for old Teddy (Vera Larkin's husband Edward Thomas Larkins). No one had seen him. He hadn't been to the pub..."

Earlier that day, Vera Larkin had gone to the Post Office to send a telegram. Postal assistant Pam Carmichael was to later recall that she seemed 'miles away'. Pam went to the Larkins' home at about 11am to deliver a return telegram to find no one there. However, she noticed a checked blanket heaped on a mattress on the veranda, plus an axe, a shovel and a few empty bottles of beer. Later, the blood stained body of Edward Thomas Larkin was discovered wedged between two mattresses on the Larkin family home veranda. His head had been split open with an axe. A report appeared in the Saturday edition of The Advertiser, March 5, 1966 (see next page)

The Larkin's house was directly opposite Marree Hospital and close to other facilities, including the police station. Nurses knew of the Larkin family and had seen and heard Teddy Larkin's cruelty towards his wife. Alison Redden described Teddy Larkin as 'vile and evil'. She could not think of a worse human being. At that time, Teddy was in the local police cells about once a month. While there, he admitted to Grant that he often tied his wife to a bed and invited his fellow railway workers to have their way with his bound and helpless wife. After killing her husband, Vera Larkin over-dosed on sleeping tablets in a vain attempt to

Marree Death Inquiry

Police suspect foul play may have been involved in the death of a 66-year-old man at Marree. The man, Edward Thomas Larkin, was found dead in his bed about 1pm yesterday by his son and daughter. He had a wound in the back of his head, which police believe may have been caused by an axe found nearby. The children, aged about eight and 11, had returned home from school for lunch. They ran to the Marree Police Station a short distance away for help. A doctor who examined the body said the man had been dead for about 12 hours. Within three hours of the report, Detectives D. Hunt and C.E. Watkins of Port Augusta, were in Marree starting enquiries. "The Royal Flying Doctor Service gave us a lift in one of its planes and saved us the usual seven-hour trip," Detective Hunt said last night. He said investigations were continuing and foul play was suspected. Detective Hunt said he would bring the body to Adelaide today for a post mortem examination. Sergeant D. Dahlitz and First Class Constable G. Redden of Marree are also investigating.

commit suicide. Marree's nursing sisters, Harley and Walklate are believed responsible for having helped save Mrs Larkin's life. Mrs Larkin was first flown to Port Augusta, then to Royal Adelaide Hospital, where police caught up with her.

A further article appeared in the Monday edition of The Advertiser on March 7, 1966:

Wife Charged in Hospital

At a bedside court in the Royal Adelaide Hospital yesterday a 45-year-old woman was charged with the murder of her 66-year-old husband at Marree on Friday. Vera Larkin, part Aborigine, charged with the murder of Edward Thomas Larkin, father of 11 children, was remanded by D.F. Wilson, CSM, to appear in the Marree Court on April 19. Sergeant J.F. Minagall prosecuted at the short sitting. Mrs Larkin will remain under police guard while in hospital, which is expected to be for another two days. Mr Larkin was found dead in bed about 1pm on Friday.

A chilling irony to this story is that the Larkin family home was once the residence of the ill-fated Page family, who had perished in the Outback.

During the Larkin murder inquiry, I could not help but feel for Vera Larkin, as did many others. They had 11 children – Maxwell, Peter, Kenny, John, Raelene, Robert, Elaine, Christopher, Joylene, Charlie and Eddie. The two Marree nurses, who had helped save Mrs Larkin's life, were distributing all manner of tranquillisers about Marree in an attempt to help townsfolk cope with the trauma of the killing. As for Vera, she was acquitted of murder, the judge saying she had suffered enough for the constant cruelty and torture her husband inflicted upon her.

During my time in the Outback, Marree was the rail head, a place where the cattle were sorted and sent by train to Adelaide. It was also a supply hub and a social nexus. Shaped by this harsh environment, its various roles and the characters that lived and visited there, it was the heartbeat of our vast stretch of bush. With all its rough and raw edges, it typified the Outback. The character of the Australian bush is indelibly etched on its 'face'.

Thunder Down Under 11

Rita never used the toilet on the big sand hill near the house. However, there were occasions when she wandered near the toilet and the noise of the "creepy crawlies" within the confines of the dunny got the better of her. One day, late in the morning, Rita rushed up to me, sheer horror on her face. "Please missus," she pleaded. "Can you do something about the bugs in the toilet on the hill. I think there's a snake there."

My instincts told me I needed to investigate straight away. The toilet had been a lonely fixture on the sand hill behind Mungeranie Station homestead for many years. The proverbial outback "dunny" was the usual corrugated iron structure; magnificent in its isolation – a bastion of the pioneering lifestyle. The dunny, with its long drop, hidden behind the wooden door that sometimes swung wildly in the sandblasted wind of the plain, was an unsung feature on the Track. The odd drover might 'spend a penny' there, but usually it was Eric's cousin, Phillip Oldfield, or the children's then governess, Miss Elly, who frequented the little outpost on the hill. There they could enjoy peace and quiet, an ideal place

to smoke in silence. Like those Lancaster Bomber heroes high above occupied Europe a few years before, heads bowed over their bomb sights, they made the long drop of their cigarette butts with uncanny accuracy. Those smoking as they sat on the throne above the long drop, were, if you cared to measure it, a good three metres from the top of the toilet seat to the bottom of the hole.

Mungeranie Station homestead had a number of good, functional toilets on site. The main homestead had a porcelain pot with a fine wooden lid and chain to help rush waste to the septic tank, about which you would invariably find sodden ground in which grew the odd vegetable; a place where the ducks and the chooks scrounged for scraps.

Unfortunately, the outside dunny attracted a number of most unwelcome guests including an amazing assortment of insects, spiders, vermin and snakes. Redback spiders liked to congregate there, sometimes in a dark corner of the corrugated iron, but usually under the dunny seat where they found sanctuary. Sometimes, a snake would slither stealthily in the outhouse, patiently awaiting its chance to nail a mouse. More often than not, the snake would miss the rodent and in so doing scare the hell out of anyone caught short.

It was, however, the insects, flies and other bugs which caused the most annoyance. At about the end of 1968, the bugs' strange scraping noises in the dunny became a source of genuine fear for Phillip, Miss Elly and Rita. It was up to me to investigate and reassure Rita that all was well – that the dunny was perfectly safe to use. I went into the store near our garage, which adjoined the main part of the homestead, where we kept

all manner of non-perishable foodstuffs, along with household essentials and fuel. If there was vermin, even a snake down the long drop of the toilet, I knew just the thing to fix them. I thought I would put some Shell-Tox liquid spray, used in insect guns, down the toilet, but unfortunately there was none in the store. So, I took a bucket and went to the 44-gallon (200 litre) kerosene drum. As hard as I pumped, nothing came out of the kerosene line. Then I spotted the petrol drum and happily the fuel flowed a treat. Armed with a bucket of petrol, I headed across the yard on my way up to the toilet on the hill. When I had walked halfway across the yard I noticed Miss Elly, the governess, the girl responsible for caring for and educating the children, hanging out her washing.

"Where are you going, missus?" she asked cheerily. "Oh," I said, a little startled, for I was on a mission, "Up to the toilet."

I walked up the hill of sand, opened the toilet door and tipped the petrol down the big drop. Noticing a candle, matches and an old magazine lying on the end of the toilet seat, which was basically a plank with a hole in it, I thought if I lit a magazine and threw it down the hole, I would get rid of all the bugs and a snake in one swift action. I remember taking the magazine in one hand and lighting it with the matches, the bucket poised over the long drop. As I did, there was mighty roar. The bucket dropped its exploding contents. I was looking down the toilet. Flames whooshed upwards at tremendous speed and I jumped out of the outhouse, away from danger. I felt my face. I was okay. I wasn't burnt, but I was minus a fair bit of my hair, plus eyebrows and eye lashes. All the sides of the toilet hole had been blown away, leaving the toilet seat

balancing precariously on its blasted supports. There was not a cobweb left in sight. Even had I not been five months pregnant with my third child, Martin, it was a silly thing to have done.

Thankfully, I was okay in a physical sense, but I was shaking from the shock. As I headed for the house, I saw the governess, still there, standing in the sunshine, hanging out the washing. Miss Elly sang out, "What happened". She could see I was shaking, pale and dishevelled. I told her. She said, "Oh, thank God you lit it. When I sit there I always throw my cigarette butts down the toilet." I giggle thinking about it now, wondering what people would have said at my funeral if I hadn't survived the blast.

Another 'feature' of the home was the school room, constructed by Eric by cordoning off one corner of the veranda and installing windows – ensuring the children had a view and fresh air. When Susan and Kenneth reached school age, they studied via correspondence under the guidance of the governess in the school room. The alternative was to attend a boarding school. Separation from families and time lags associated with mail deliveries were the respective drawbacks of these. Our children were taught using a curriculum similar to those used in primary schools in the city.

The only break in children's study routine was a half hour wireless session each weekday morning tuning into the School of the Air on the RFDS radio. Apart from being a link to the outside world from our isolated station, the School of the Air, which gained international exposure in the late 1960's through the television series, Skippy the Bush Kangaroo, was a valuable supplementary part of the children's education. It

THUNDER DOWN UNDER

linked them with a teacher, who supported and guided them in their studies. It also linked them with other children in the outback, who they could converse with over the airwaves.

Graham Pitts, who in 1962 became director of the now world recognised RFDS at Port Augusta, had a direct hand in helping establish the school. In his biography, completed by his son David after his death in 1992, Graham wrote of Miss Adelaide Miethke, the first woman Inspector of Schools and RFDS Council member, who hit upon the idea of supplementing the normal correspondence education for children in isolated areas by way of lessons via radio. Miss Miethke, who I met during my children's schooling, was almost a member of the Pitts family, given she was godmother to Graham's grandson, Jeffrey. This no doubt gave her an insight into the unmet needs of children studying in the Outback. Graham's journal documents the inception of the service:

"Miss Miethke discussed the idea with me when she was staying with us and I assured her it was technically possible, but there was need for additional radio equipment. Her idea was a bit radical for some in authority, but she (Miss Miethke) was a determined and persuasive woman and she eventually convinced both the RDFS and the SA Education Department to commence the scheme on a trial basis."

The first broadcast was on May 20, 1950. Graham took care of the program's technical side. He had discovered a large quantity of ex-service equipment was to be auctioned in Darwin and negotiated to buy, before the auction, four powerful transmitters. The price was a veritable pittance. The transmitters had been intended for Morse Code transmission

but Graham recognised their great value and two first-class telephone transmitters were created out of the four Morse Code transmitters. Graham was commissioned to design and fashion the studio equipment. It proved a complicated task but Graham succeeded in getting the mostly volunteer teachers to man the airways and create a wonderful educational and social support for children of the Outback.

Graham had extensive experience with the RFDS. Long before taking over as RFDS director at Port Augusta, he was based with the service at Alice Springs where he was exposed to extraordinary circumstances and tales of those in remote areas desperate for medical help. One arose at small gold mines at the Granites and Tanami Fields northwest of Alice where exploratory drilling was being carried out. The RFDS base at Alice Springs received a faint radio message. There was a pause, then word came through, "There's a bloke out here whose cut his throat." Unable to comprehend the extent of the message, the base operator said, "Can you please confirm your message and give your location?" The faint voice repeated the grim message, "That's right, he's cut his throat." Graham immediately rang the doctor next door, "Get over here quickly, we've got a bloke with his throat cut." He outlines the story in his autobiography.

The man on the wireless turned out to be the MIM head driller. He had forced entry into the Chapman's house the (radio) transceiver but he had never used one before. The mail truck had arrived the previous day carrying lots of cheap wine. They had apparently all been on the booze.

The doctor raced in, asked a couple of questions then said, "You will have to sew him up or he will die."

The foreman said, "I can't do that, there's blood everywhere."

Doctor: "You must do it, otherwise he will die."

Foreman: "I haven't anything to do with it."

Doctor: "Have you a bag needle and string?"

Foreman: "Yes, I will have to go and get them."

Doctor: "Ok, hurry up or he will die."

Foreman: "he must be dead, he's stopped breathing."

Doctor: "Has he any pulse?"

Foreman: "No."

Doctor: "Ok, he's dead."

As the death was not due to natural causes, a post mortem was necessary. Because of the heat, the doctor decided to fly out at first light the next day and do the job in the shade under the wing of the plane. I arranged for them to have a table out at the strip and to dig a grave close by. When the doctor arrived back from carrying out the post mortem, he was still laughing. On landing at the Granites he found most of the party were still on the booze.

The camp cook was waiting for him, complete with chef's hat and white coat. He had previously worked in an abattoir and he wanted to assist with the post mortem. He had brought all his knives along to do the job. To avoid problems the doctor decided to let the cook assist. He just told him where to cut and the cook did the job. Apparently all had a good time. The Doc was satisfied as to the cause of death and duly signed the (death) certificate.

I believe that just about anyone who has spent a substantial amount of time in the Outback has had perhaps

less extraordinary but critically important, experience with the RFDS. In addition to help given to our family and the life-saving attention Miss Raelene received after the snake bite, our governess, Miss Elly, was also saved by the RFDS. The lass complained of a pain in her side and said she had previously had problems with her appendix. I contacted the RFDS via the wireless radio and the girl sat beside me as the doctor gave instructions over the air. When I pressed her side, she doubled up in pain. I had been through the trauma of experiencing appendicitis and I knew she was in trouble. The RFDS said a plane was on its way. Miss Elly was flown to Port Augusta that day. It was touch and go. We learnt later that her appendix would have burst had the RFDS not come straight away.

Invaluable direction was also given once when Kenneth had contracted an infection and had a high temperature. The RFDS doctor told me over the wireless to administer penicillin and how to do it. I was terrified. The needle I was to use was huge and the thought of plunging it into my own son, who was only seven years old, was horrendous. Kenneth, although unaware of the consequences should I hit an artery, was crying at the prospect, sensing my fear. It was bedlam. In hindsight, the RFDS doctor forced me to gather my wits and do it, saying he would not get off the radio until the injection had been given. With a governess holding Kenneth down and swabbing his bottom, I did the job. Thinking about the whole experience still gives me shivers.

On yet another occasion, when Susan and Kenneth had contracted chicken pox and had high temperatures, I was in a panic and spoke over the radio with the nursing sisters at

Marree, who assured me that their temperatures would fall, spots would appear, and they would be fine. It was such a comfort to have such medical help at hand.

Another instance when the RFDS' full emergency service was needed was when a road gang worker was camping at Mungeranie and rolled into a campfire. The man was seriously drunk and badly burnt on one side, yet took some time to feel the pain. Without help from the RFDS, I doubt he would have survived.

Similar stories hail from other stations. At Kalamurina, for example, a governess was bitten by a red-back spider and fell violently ill. She was rescued by the RFDS. So too, a man at Kalamurina Station was flown out by the RFDS after he cut off a good deal of his foot when the axe he was using to chop firewood fell foul.

Many such stories with an RFDS connection have an anything but ordinary background and often involve colourful characters, with the rough and tumble harshness of the Outback inevitably affecting them. Rarely were solutions 'clear cut'. This was all 'brought home' to me when Eric and his cousin, Bryan, came home early from a muster in the Toyota truck. They came inside, sat down, threw their hats on the floor and settled down with a few beers. Then I heard, Eric say, "Jeez, the bugger kept falling off the truck." "Yeah," said Bryan casually, "ya think he'd stay on board until we got home."

I was intrigued and asked Eric what was going on and who had fallen off the truck. "The Abo' stockman," Eric replied, amazed that I needed to ask. "I don't think he's alive," Eric continued. "What do you think, Blacky (Bryan's nick-name)?" Bryan replied, "No, I don't think so. He's a goner."

The two men took the top off another bottle of beer. "Where is he?" I demanded. "In the garage," one of the men volunteered in a feeble voice. I rushed to the garage, examined the stockman and found he had a very weak pulse. "Well then," I said angrily, "I have news for you. You two better get him out of the garage. Bring him inside, shower him and dress him in your pyjamas Eric and put him in the bed on the veranda." "My pyjamas?" Eric asked indignantly. "Yes. Your pyjamas!"

Thrown by my assertiveness, Eric and Bryan obeyed my instructions to the letter and I contacted the RFDS. The RFDS doctor gave instructions about how to administer morphine as the stockman was moaning in pain. We managed to give him the required dose by injection with a syringe – eventually. We did not realise that to use the plunger properly you had to push it down to break the seal of the morphine bottle before administering the injection. That is a good example of our ignorance. After five unsuccessful attempts, it worked a treat and within a relatively short time, the poor man was sitting up in bed eating custard.

The RFDS doctor arrived late that day and flew the stockman to hospital. Sadly, he died about six months later. Apparently, he had a terminal liver complaint, although falling off the truck that day would not have helped his chances of longevity.

There were and are many unsung heroes among the men and women of the RFDS. Dr John Mickan, who joined the RFDS in 1953 and served for 12 years, cites the service's pilots as being especially important. Night landings, with car headlights at the end of the strip and two-thirds the way along

it, would be particularly dangerous according to Dr Mickan. He said, "The pilot knew he had enough runway left for a safe landing so long as he got the aircraft's nose down, wheels touching the ground, before reaching the car stationed two-thirds the way along the airstrip. If he failed to touch down before reaching the car two-thirds along the airstrip, the pilot would abort the landing, climb, circle and prepare for another approach to land."

Just before our governess was bitten by a snake and saved by the RFDS, Dr Mickan and Dr Robert Cooter made a significant discovery associated with the deaths of 20 children and young adults in Port Augusta, Port Pirie and Kadina. They suspected the source of the problem was a pollutant in water from the Morgan-Whyalla pipeline. They ultimately established that live amoeba in the water were causing amoebic meningitis. Dr Mickan was awarded a Member of the Order of Australia (AM) for this groundbreaking medical research and his contribution to rural medicine with the RFDS research, in the 2010 Queen's Birthday Honours List.

There were also many tragedies on the Track when it was too late for the RFDS to help. Jimmy Dunn, in his self-published book, *'The Cooper's Coming'*, outlines the complexities in writing of a young man who was drowned on Cooper Creek on the night of July 29, 1963:

The E&WS men manning the punt were about to cross over to the Marree side of the river to their camp when a truck loaded with chilled rabbits arrived. The men thought that the load would be too heavy for the punt and they should wait until next morning

and assess the situation – perhaps unload some of the cargo. The truck driver was in a panic as his schedule was to travel to Adelaide overnight or his cargo would go 'off'. He convinced the boys to give it a go. As soon as the punt got into the main stream, it tilted over and put the truck off centre and in a matter of seconds it slid into the river. The unfortunate 20-year-old E&WS employee, Richard Pearce, was on that side of the punt and he disappeared into the water. His body was never recovered. The remaining E&WS employee who was nominally in charge knew he should have been guided by his better judgement. The boy's body was carried out into a vast expanse of water and there was no manoeuvrable boat to go searching. All the E&WS man could do was to get down to Etadunna to report the matter on the emergency RFDS channel to Port Augusta.

Jimmy Dunn has more recently been trying to document tragedies along the Track but the pursuit of official documentation from a relatively non-technological period has been frustrating. I fear that many of the instances, like the often dramatic and life-saving work of the RFDS over the decades of the previous century, will become lost in a melee of fading paperwork.

Mungeranie Homestead 1960

Swallowing Poison

The isolation was so great and Eric was away in camp so often that we rarely went out. I found myself being with just my children more and more. Susan and Kenneth were, of course, a delight and a comfort to me. Although they were sometimes mischievous, they were veritable angels compared with children at some of the other stations.

Adding to the children's mischief was that Eric and the jackeroos were careless in leaving ladders and dangerous chemicals lying about. Fuel, bottles and cans of insecticide, petrol, kerosene and detergent were easily found by the children in and about the homestead. Eric's carelessness with strychnine baits cost our border-collie dog, Skippy, his life and it almost proved the end for Kenneth. Once, as a tiny tot, I saw Kenneth standing in the front seat of the Toyota, pretending he was driving. He had picked up a bottle of strychnine, which he had found in driver's side compartment. I was horrified to see that the lid of the bottle of poison was off. I called Eric, who immediately grabbed Kenneth and took him to a tap where he washed his mouth out. It was a close call.

For some reason, we once allowed Susan and Kenneth to go out in the buckboard of the dogger-man, whose full-time job was to shoot or bait dingoes. I don't know why I allowed Kenneth to go, given the dogger-man had strychnine poison baits and Kenneth would eat or drink just about anything. Adding to the potential danger was that a dingo could be quite cunning and ferocious when its life was endangered. On this occasion, the dogger intended to catch a bitch and tie up the wounded animal so its cries of pain would attract other dingoes that could be shot from close range. Today, the public and the RSPCA would be horrified. The dogger aimed to set a 'green trap' – a steel dog trap that would hold a dog's leg, restricting its movement, rather than fatally injuring it. I thought this method was cruel and suggested he tried bait laced with Phenobarbitone tablets, thinking that the dingo would fall asleep and the dogger could then tie it to a tree.

The baits were laid the night before Susan, Kenneth and our dogs went out with the dogger. The party returned later in the morning without a dingo. The children were fine but with a decidedly groggy Snowy. Our little Jack Russell had eaten one of the baits and kept falling asleep. We fought to keep him awake all day and continually plied him with condensed milk and coffee. The marvellous little dog, Eric's favourite, had the heart of a lion and thankfully survived this episode.

We had added Snowy to our household when some tourists, passing through Mungeranie, indicated that they were going to have him put down. Eric chimed in, "No, don't do that, give 'im to me". We all became very fond of Snowy, who definitely considered Eric his mate and the head of the pack.

Snowy's 'rite of passage' to 'second in line' from Eric, seemed to come in the Toyota, with a fiercely fought contest between him and the children for his 'right' to sit alongside Eric. Once there, the little fellow would look at Eric adoringly.

We were lucky Snowy never died from injuries or poisoning in the Outback. Some of the potential dangers were very close to the homestead. One was a bullock carcase, laced with strychnine. It was to be used as bait to catch a large white and tan dingo that had cunningly evaded rifle shots and the usual strychnine baits. The carcase was encircled by a line of treacle which was also laced with strychnine. The line was then covered by fine sand. Bill Gwydir had suggested this ruse. The idea was that the dingo would investigate the carcase. It would tread in the poisoned treacle and would go away and lick its paws, ingesting the poison. Crows began to feed on the dead carcase and quickly regurgitated the poisoned meat. Luckily, we were able to keep Snowy away from the deadly poison. The dingo did take the bait and eventually died.

Life on Mungeranie Station was heaven for Kenneth. He loved the freedom of the bush and all that living on a cattle station entailed. From the age of three, he walked everywhere with Susan. They were inseparable, always getting into mischief through curiosity and a sense of adventure. There was always something to do, somewhere to go. Invariably, Susan would show Kenneth the way. She was the real mischief-maker, instigating trouble the pair of them managed to find.

When aged three and four years respectively, Kenneth and Susan climbed the Dunlight, which we called the free light tower as the massive windmill produced 32 volts of electricity

NO BEATING ABOUT THE BUSH

which powered the lights in the homestead. One of the workers had conveniently left a ladder leaning against the tower. When I emerged from the house, I was greeted with "look at us, Mum". They were at the very top of the tower, each holding on with one hand and waving with the other. Thankfully, it was a still daylight and the blades of the windmill were not turning, otherwise the children would have been injured or worse, knocked off the little platform. I was terrified of heights, but somehow I climbed the tower and brought them down one by one, greatly relieved they had survived another adventure.

A day of near tragedy occured when Kenneth swallowed kerosene. Eric and I had been concerned for some time with the children's fascination with the fuel drum. For safety reasons, we had the pump handle wired so they couldn't easily extract kerosene or petrol. Kenneth and Susan had returned from a walk on a hot day down to the bore drain and were thirsty. Kenneth tried unsuccessfully to drink from the fuel drum. Susan said, "If you suck really hard you'll get some." Kenneth consumed a lot of kerosene. He was violently ill and needed medical attention straight away. We called on the radio to the RFDS and I spoke to a doctor at the Port Augusta Base. After many questions were answered, the Doctor decided the matter was serious enough for Kenneth to be flown to hospital in Port Augusta.

It was touch and go on that horrible journey. By the time the small aircraft took off, with Kenneth in a makeshift bed and myself in the back seat, the situation was already dire. The aircraft hit an air pocket flying over St Mary's Peak in the Flinders Ranges, Kenneth convulsed. Rigid with the 'fit', I struggled unsuccessfully to turn him over so he would not choke. Luckily,

the co-pilot managed to straddle between the seats and help with the lift. It was a lifesaving moment and Kenneth reached Port Augusta Hospital safely. Within a couple of days Kenneth was out of danger and soon right back into mischief.

Kenneth loved his Dad, always happy to be with him in the Toyota, driving through the countryside, tending the cattle, visiting the bore drain or looking for birds. Eric taught Kenneth all the ways of station work: how to make greenhide ropes, (he still owns his father's old rope-making machine); mustering cattle and how the men rounded-up, roped and branded calves.

When they were very young, Susan and Kenneth would drive the Toyota. Susan stood in the driver's seat steering the vehicle and Kenneth sat on the floor changing gears. Eric found the children's ability with the Toyota quite useful as he could jump out and chase the cattle by foot, or drive them along while Susan and Kenneth followed in the vehicle.

Susan and Kenneth would also go into the 'calfateria' enclosure together and the calves would follow them. They had names for all my poddy calves. Once Susan put out her hand and the calf opened its mouth and her little arm seemed to 'disappear' down it's throat.

In the 1960's, Dr Spock was all the rage. His books told mothers of the world how to bring up their children. Kenneth was so mischievous and was always delving into drawers and tins in the shed, that we decided to use Dr Spock's advice and explain the dangers of things like poisoning. Eric took Kenneth to where he had found a dead calf on a sand hill and explained that he could end up like the dead calf if he swallowed poison. Soon after that lesson, Kenneth walked into the lounge room

and admitted that he had eaten some Ratsack! We contacted the RFDS doctor and received instructions to keep up a supply of water to Kenneth, monitor his temperature and inspect his body regularly for any sign of bruising. The time passed and Kenneth was okay. My hair just turned a little greyer.

One of the problems with children living in isolation and not mixing with lots of other children is that when they went to the city and were with other children, they seemed more vulnerable to picking up a virus. Both Susan and Kenneth had been immunised against whooping cough, but they contracted a particular strain – apparently there are five – and were hospitalised. Poor Kenneth was so sick and lost weight to such an extent that he looked like those terrible images of the children who suffered in the Nazi death camps. Dr David David, now world famous for his pioneering work at the Australian Craniofacial Unit in Adelaide, saved Kenneth's life with his care and expertise.

Despite the constant worries of the children getting up to mischief, most of their 'adventures' were harmless. For example, capitalising on the snake problem, Susan and Kenny got up to all sorts of hijinks with a rubber snake, which had been given to them at the Royal Adelaide Show. It was perfect to terrorise any visitor who stayed overnight. The children sometimes draped the snake across the arm of a chair or placed it under the sheets of the guest's bed. When I finally found the snake and confiscated it, there were lots of tears from my beautiful but mischievous children. They made life sing.

NO BEATING ABOUT THE BUSH

Drought and Flooding Rains

13

DROUGHT

The northern inland part of South Australia experienced prolonged drought during the 1918-1949 period. There were, of course, times when the Diamantina River flooded but drought was the norm in that period. Like a cancer, drought crept up on you until the land was almost devoid of any vegetation and the seemingly interminable dust prevailed.

Before the Europeans invaded Australia, the Indigenous people simply moved to greener pastures when drought threatened. They had an intuitive or informed 'compass' that led them to places that were bountiful. The trappings of white Australian lifestyle, of owning a home and a property, did not accommodate such flexibility in changing conditions and people stayed on their land until a lack of water forced them out, or the bank foreclosed on outstanding loans.

In the 1950's, most of the stations in and about the Track were under the influence of drought. Yet, when we arrived on Mungeranie Station as a married couple in 1960, the pastures were green and there were masses of wildflowers –

blooms danced in the sun for as far as the eye could see. It was magnificent until the drought took hold of Mungeranie.

Over the first three years of drought at the property, our average annual rainfall was 35 points. The worst part was watching in vain as the cattle and the horses died of hunger. We had the heartbreaking memory of seeing 90 horses die in agony about our homestead. I would lie in bed and hear the cries of those animals and plead with my husband, "For God's sake Eric, do something, I can't stand it!" On one occasion, I didn't realise I was begging him to put down one of his favourite horses. It was a pet and mate. With a hint of a tear in his eye, Eric said to me, "Val, I can't do it. It's one of my favourites. I can't shoot it." When we got up in the morning, the horse was lying on its side. The poor animal had died during the night.

During the drought, the South Australian Government helped by sending in bales of hay. There was never enough and the quality was questionable as it was full of corkscrew shaped grass seeds which would often pierce the gums of the animals and eventually work their way into their bloodstream. It was a terrible sight to see these poor, half-starved horses and cattle, their gums bleeding, standing in melancholy groups. I would put my hand into the animal's mouth and scrape out the grass seeds. The poor animals were simply too weak to care.

The drought seemed to encourage the wind to stir up the dust and we had up to three dust storms every day. No sooner would we shovel dust from the rooms and the verandah into a wheelbarrow and dispose of it another dust storm would hit. The red sand would build-up to the point where it threatened to spill over a wall, nearly a metre high, which surrounded

the homestead. However, our main concern was how to keep the cattle alive. We had plenty of water but there was no feed. Cousin Bryan from Etadunna offered to let us take our cattle to Bultarkinina, 27 kilometres from the station.

Uncle Bland Oldfield and his team of Aboriginal stockmen set off with 2000 head of our cattle, including the first poddy calf I had raised. She had grown into a beautiful red cow, with a calf at foot. Before they left, I went to say good bye to Sally. Armed with a slice of bread covered with Golden Syrup and standing on the back of the Toyota, I started to call her name. I made sure I wore an apron over my jeans because there was no way Sally would appear if she thought the person calling her was a man. Sally hated men. Within minutes, Sally spotted me and appeared. She bunted me gently with her horns and quickly downed her favourite treat. The stockmen nearly fell off their horses. I got a big surprise too for Sally had two calves at foot. She must have delivered the second just hours beforehand. I felt elated, like a grand mother. That night, Uncle Bland and his men headed off, droving the cattle, convinced Sally would not leave the mob. Next morning she stood, with her two calves, within metres of our house, waiting for her treat.

The cattle arrived in Bultarkinina, very weak but in reasonable shape given the lack of food and the long distance travelled. Eric took an old caravan and set up camp there. He came home once a week for a few hours but was fighting a losing battle at the camp. The weak cattle were an obvious target for dingoes and when a cow looked like dying, Eric would bring it's calf home for me to hand rear. I would cook bread, cake and meat for him to take back to Bultarkinina. We lived in this

way for several months until I decided that the children and I would be better off at the camp with Eric.

The caravan where we stayed was under a big coolabah tree. It was so hot in the middle of the day that crows dropped dead out of the branches of the tree and landed with a crash on the caravan roof. I hung wet nappies from the caravan window in the hope that a gentle breeze would spring up and fan cooled air over the children, enabling them to have an afternoon sleep.

Even in drought, there can be an odd shower of rain and the grass seems to grow at the very hint of moisture. When we discovered a little patch of grass within reasonable range, we moved the cattle to it, but usually they had to walk long distances to the feed. We all used to go out in the Toyota, load up with squash bush and bring it in for the cattle. Squash bush was a remarkable plant and proved ideal for our desperate situation because it was nutritious and a source of water. It was the only feed within cooee (not far away) of the caravan and it helped to keep some of the cattle alive.

Our weak and emaciated calves were often preyed upon by dingoes, which roamed about all day and howled all night. They would bite the calves' legs which often turned septic and the wounds attracted flies and later the maggots, weakening them further. Their sheer vulnerability invited more dingo attacks. Every day we would drag dead cattle into a heap and set them alight. The smell was vile.

The dam where the men collected their drinking water also proved a trap for unwary cattle that would get bogged at its edge. It was around the dam that the men would set strychnine baits for the dingoes. However, in their dying throes, some

would enter the water and drop dead, polluting the drinking water. This dam was our only source of water but in the bush, people knew that Anchor brand raspberry cordial somehow 'purified' it. We drank the putrid green dam water with the cordial added and luckily no-one became ill.

One evening, we were sitting in chairs outside the caravan, playing a game of poker under a moonlit sky and a fox ambled up from under the coolabah tree and calmly sat down beside me. I presumed it had never seen a human before and had no fear at all. Perhaps the heat was getting to every living creature.

Kenneth had his birthday while we were at Bultarkinina and I decided to cook a birthday cake on my trusty Portagas stove. It must have been 45 degrees Celsius in the shade that day and the softening candles had to be propped up with match sticks. Kenneth blew out his three candles with one big huff and puff. We all had a great day. Living in the caravan at Bultarkinina was a rough life. I would bathe Susan and Kenneth in an old tin drum and our only toilet was created by digging a hole with a shovel.

My Jersey milking cow at Bultarkinina struggled to survive. She was beyond yielding milk and her last hours were spent propped up, tethered to a tree. We believed that she might have lived if we kept her upright, but she died tethered to the tree.

A few days after the fox appeared in the middle of the night, an Aboriginal track rider turned up and handed me a bag, smiled and said gently, "Here's some pretty stones for you, missus." They were a delight. Bultarkinina was a carpet of polished stones, petrified wood and crystals, all shaped and

polished by the winds over thousands and possibly millions of years. They were formed above the Great Artesian Basin over sedimentary strata deposited throughout the area 500 million years ago. No wonder they call it the Sturt Stony Desert. The oxide 'coating' on the stones can be likened to 'desert varnish'. They caused much distress to Captain Charles Sturt's expedition horses, cutting and bruising their hooves. Susan, Kenneth and I loved roaming the land looking for interesting stones, even though the Sturt Stony Desert is said to have terrain resembling that of Mars. So visually alike, the Stony Desert was chosen by the Mars Society as one of four possible sites throughout the world to establish an analogue research station. Bulktarkinina certainly was a bit like living on another planet, isolated and miles from real civilisation. The stone pickings kept the children and myself very busy as there were literally millions to choose from including red, cream, purple, black, almost all the colours of the rainbow. It gave me my first knowledge of the array of extraordinary crystals and stones to be found in the Outback.

I recognised the stones posed a good business opportunity. On my return to Mungeranie, using a tumbler and diamond saw, I cut, polished and set the stones in a variety of settings, often working until the wee hours. Happily, I had a ready market from travellers passing through Mungeranie. The jewellery featured agate, crystals and petrified wood. Had it not been for my time at Bultarkininia, my jewellery making enterprise is unlikely to have come about.

After four weeks roughing it in the caravan at Bultarkinina, I decided to pack up and go back to Mungeranie. The drought had taken its toll. It was good to be back at the house, although

we had let the staff go because we could not afford to pay them and I was again very lonely without Eric. I felt so sorry for him. He was a wonderful worker and tried so hard but the drought went on and on. Those drought years were awful.

After three years without a rain shower to speak of, I walked into the kitchen one night to find a mass of huge ants across the floor. They were not aggressive, but they were punctual, turning up in their thousands and covering the kitchen floor on each of the next few nights. At one meal, ants had us in stitches laughing. The Minister of Lands was visiting. We tried to turn the meal into an 'occasion' in his honour. The formal dining room was set with our best china and we restrained our normal fairly boisterous behaviour. Unfortunately, the Minister was seated near the sugar bowl. He took the lid off and the angry ants reared up causing the Minister to gasp with shock. All the table guests covered their mouths in an effort to stifle their amusement.

We named the hard little critters with jointed berry-like bodies in our kitchen Eight O'Clock Ants, because they came en-masse at 8pm. After a few days of the ants appearing, the heavens opened up and it poured with rain. Interestingly, just before the rains came, cows dropped their calves and baby rabbits appeared. The animals knew.

* * * * * * *

FLOOD

When it rains in the Outback, it pours. There was widespread flooding of the Track in the years 1883, 1887, 1905, 1907 and 1909. A year after the big flood of 1887, William Crombie first camped at Mungeranie. He was among the few regular travellers along the track. Mungeranie was ideal for his purpose and in 1888 he bought a virgin block so he had a place to spell (rest) his horses.

Within two years, Crombie could sell water for passing cattle from the recently-completed government bore. Before the government sunk the bore, Crombie used his team horses to pull the whip which drew the water from the well. With the bore, there was water aplenty for his own needs and travellers passing through the property.

William Crombie was born in Adelaide in 1867 and had begun his working life as a blacksmith's apprentice. In 1891 he married Susan Scobie, daughter of a Scottish station owner at nearby Mulka. Together, they reared 11 children and made the name Crombie synonymous with that of the Track and the Far North. Grace Sampson, who became a good friend of Susan Crombie, ran the original hotel at Mungeranie. A police station was established there in 1903, but William was concerned about the lack of educational facilities for their children. On October 10, 1903 William wrote to the Adelaide-based Minister of Education:

"It only requires twelve children of a school going age to get a government teacher in a district. I beg to state that I have six of my own family of a school going age and that being only

a working man I can ill afford to pay the salary of a teacher and it is quite beyond me to board my children. Can you assist me in any way as my children must have some education."

The Minister did not reply to Crombie, who was left to contemplate what to do. Crombie was a determined soul, on April 24, 1906, he wrote to the Minister again. This time his letter was decidedly more conciliatory. He offered to pay a generous £20 a year, plus board and lodgings for a female teacher to run the Mungeranie School. He had supplied references of the highest order from three eminent citizens, Sir Sydney Kidman, John Kingsmill and A Helling, but still got nowhere with his request. It was 10 years, in 1915 when a teacher finally arrived to start the Mungeranie School.

Before 1910, William was a Justice of the Peace, but lost his appointment after being convicted of assaulting an Aboriginal man at Hergott Springs. The German-sounding name of the town was changed to Marree during World War I. Susan and William Crombie had a total of 11 children, five girls and six boys, although one of twin girls died as a baby and the second twin was tragically killed in an accident. Both are buried in the little cemetery at Mungeranie.

With such a large family, William built a grand 18-roomed house on the property, but it was washed away in the 1905 flood. An Aboriginal family saved the children by rushing to the homestead, sweeping them up in their arms and taking them safely to the high ground on top of a sand hill. After the water subsided, the Crombie family piano was found an incredible 10.5 kilometres away.

William was a great horse lover and breeder. At one time,

he worked the Track mail run with his great 15 hands Chestnut horse, Berunga (by Juggler out of Dawn). He bred some of the best camp drafting horses ever seen on the Track. During World War I, he sold a number of his horses – gunners and remount specialists to the Indian Army.

The flood of 1905 destroyed the Crombie home and then again the rebuilt homestead was washed away two years later in 1907. William rebuilt the homestead, this time further away from the Derwent River. The new homestead withstood the 1909 flood and was still a sturdy, thick-walled residence when I first arrived in 1960.

About the same time as the Brisbane floods of 1974, Joan and Jimmy Dunn had their homestead at Kalamurina inundated by floodwaters. Jimmy battled for ten days to save the house. He gave up the fight, when the Warburton River, fed by the swollen Diamantina and Georgina Rivers, broke through an embankment intended to protect the homestead. A board attached to a coolabah tree near a branch channel of the Diamantina River showed previous flood levels. The original marker was '13 feet'. Then, in the big flood of 1971, the marker was raised to '16.5 feet'. Jimmy Dunn clambered on to a branch and swung his axe as high as he could to chop a mark above the '22 feet' level, deciding no flood would ever exceed it. The 1974 floodwaters rose to 33 feet and the coolabah tree was washed away. As Joan, Jimmy and son Peter, 16, sat in a tent on a nearby sand hill, they watched as the floodwaters engulfed their home. Only the shiny tin roof could be seen above the grey, swirling flood waters. Sometime later, I met Joan in Adelaide. She had decided to leave her temporary home after several snakes were

found under her bed. I always said if any woman deserved a gold medal, it had to be Joan.

Jimmy Dunn lost a good deal of stock due to the flood, two horses of which he considered to be priceless and irreplaceable, being his camp horse and bronco. When the waters receded, there was a colossal job for the Dunns. They had to muster, draft and brand remaining cattle, burn carcasses of the dead animals and begin the heart-rending task of cleaning up the main house and out buildings. A few weeks later, Jimmy wiped his eyes and took another look. Two scrawny, undernourished horses came into view, his two favourite mounts had survived the raging floodwaters and its aftermath. Within a few weeks, both horses had recovered and were back to their old form and fitness.

I shall always remember the time the big drought broke. We were inside the homestead and huge rain drops hit its corrugated iron roof intermittently. They were isolated, solitary dollops. No one got excited. We had heard them before and they had come to nothing. Then the rate of dollops increased. We all stopped what we were doing and I think we all looked, in anticipation, at the ceiling. I know I did and quickly looked down again, not daring to get excited. Then a rhythm of large raindrops started. We looked to each other and said nothing. With our gazes locked in each other's, the rhythm suddenly became a solid, thunderous roar. The air groaned with hot moist heat. This was more than a tantalising few drops, or a little shower – the drought was over!

I don't remember who ran out of the house first. We jostled like broncos, trying to get through doorways all at once and charged out of the house – laughing, shrieking and

yahooing with excitement. We stretched our arms up to the sky and jumped up and down in water, fast coming up to our ankles. Thunder and lightning crashed around, as it does in the Outback, but we didn't care. We had rain – the essence of life.

We knew the water would not seep into the hard ground and would flood at least our kitchen and dining room in the homestead, but we didn't care. We didn't care about anything. We had been waiting for three years for decent rain and knew our country would soon be alive, lush, green and full of life.

We sang and danced in the rain and then jumped into the four wheel drive to have a look around the satation, the sweet smell of the rain in our nostrils. We sped down to the bore drain and watched in fascination as the power of the water rushed to flood the once bone dry ancient waterway.

The greatest experience was to stand at the head of the water of Cooper Creek, watching the water rush and spread out along the dry river bed, where it gained momentum and volume, filling up water holes and sweeping across the parched land. All manner of birdlife followed; hundreds of varieties of birds excitedly flapped their wings and sang in praise of Mother Nature.

After the rain, the country was transformed into a sea of flowers. Wildflowers seemed to appear from nowhere and the sight of that fabulous splash of colour brought immense joy to everyone. I fondly recall standing in a carpet of wildflowers, holding Susie.

The power of the water in a flood is amazing and dangerous. One time after the drought broke and during heavy rain storms, Eric had driven into Marree and upon returning

1. WE'RE BOGGED
2. MY LOVELY LASSIE WITH PEDRO
3. LETS GO SUSAN
4. CEMETERY MUNGERANIE

1. HELPING DAD BULTARKINNA
2. BATH TIME – BUSH STYLE
3. RIVER DERWENT IN FLOOD
4. DEAR AUNTIE IDA

1. FISHING COOPERS CREEK
2. I'M ENJOYING A RIDE
3. DONALD CAMPBELL WITH 'BLUEBIRD'
4. MUNGERANNIE HOMESTEAD 1940

1. MY BEAUTIFUL 17 YEAR OLD DAUGHTER
2. MARTIN & SUSAN GRADUATION
3. SUSAN, PETER & MARTIN
4. VAL WITH ONE THAT DIDN'T GET AWAY
5. LENNA & VAL, SHOPAHOLICS!
6. JOHN LETTS & VAL, FEBRUARY 2012
7. FROM LEFT, KEN, ERIC AND MARTIN

could not drive across to the homestead because the Derwent River was in full flood. I heard the familiar sound of Eric's revolver which he fired to let me know of his whereabouts. I drove to the river and saw him chest-high in water, wading through the raging river and holding a big box of bread on his head. It was a dangerous thing for him to do because he could easily have been swept away by the raging waters to his death. Thankfully, he was very strong and made it to my side of the river. He laughed casually at my concerns. We left his vehicle on the other side of the river until the waters subsided. I suppose after years of drought, Eric was not going to complain about there being too much water.

One day we happened across an extraordinary flock of Brolgas. They jumped and danced in the most amazing way. Eric and I sat transfixed, watching their dance. The curious dance of the Brolga is apparently legendary, but we really knew very little about this majestic creature. I have since learnt that June is when Brolgas in South Australia start making their way to the breeding grounds. The Brolga (botanical name *Grus rubicundus*) is the largest water bird in south-eastern Australia and one of the largest in the country. They are blue-grey or silvery-grey in colour with a bright red head and the average adult stands an elegant 1.5 metres tall. They live in and about swamps, shallow lakes, flooded grasslands and salt marshes which provide an abundant source of their favourite foods including invertebrates, seeds, shoots and bulbs. When Brolgas pair up with a mate they stay together for life, which is somewhere around seven years or more, but it's not known for sure exactly how long they can live. In the northern part of their range,

particularly in Queensland, a single flock of Brolgas can still number 12,000 birds. In the south, however, it's another story. Apart from sporadic sightings along the coast, they have pretty much disappeared from that region. So we were pretty lucky to have seen the dance of the Brolgas in the wild and a long way south of where they now thrive. The memory of the Brolgas' dance will always stay with me. It was a vision of beauty after years of desolation.

Farewell Mungeranie 14

The first six years of our marriage were brilliant. Despite the isolation and Eric being away so often, we had some terrific times. We laughed at adversity and I learnt, as Eric knew from living in the Outback all his life, to accept our lot. There was so much beauty, along with the terror, in this vast landscape and I must admit I did love him dearly. There is no way I would have stayed at Mungeranie Station for 10 years if I had not loved Eric.

As in most marriages, we had our good and our bad times. The good times were many and we made our own fun, as one had to in the Outback. Images of the good times keep flooding back to me even now, as if they happened yesterday. There was the time we dug out the bore drain to build a swimming pool and there we would swim and splash about. We would play cards, go fishing, listen to music, go for drives and meet up with friends. Many happy times!

During the rabbit plague, we all got aboard the Toyota and headed out at night time into the 'never never' to hunt rabbits. Susan, Kenneth, Eric, the station hands, governess and I went together and caught as many rabbits as we could

manage to cart home. Often, the rabbits would be caught in the headlights and would freeze momentarily. That gave us the perfect chance to pounce. A rabbit meal was something of a treat because our main meals were dominated by big lumps of roasted or boiled salted meat. I cooked the rabbits in a variety of ways, but my specialty was sweet curried rabbit.

We would travel to Cooper Creek to fish. Martin was just a toddler, so we would tether him to a tree near the riverbank with a length of rope, so he wouldn't fall into the river or wander off when we weren't looking. He would sit happily on his rug under the coolabah tree playing contentedly with his toys while we threw out our lines and exchanged stories tall and true.

There were regular outings and picnics and we were often joined by the Oldfield family from Etadunna Station. When the children were very young, Eric used to encircle our picnic spot with a trail of strychnine, a successful strategy as it transpired, to dissuade those fiery little ants which seemed to follow us into the 'never never', always trying to invade our space. I called these little creatures 'rude' ants, for they had the uncomfortable knack of attacking one's vulnerable and private parts, inflicting the most powerful bite. Their nippers seemed to be their biggest part. It always seemed to be the season for 'rude' ants, but not always for flies. When fly season came, you needed to wear a net to protect yourself from the hordes of flies.

Every three months, Eric and I would spend a week in Adelaide. It was part holiday and enabled us to go to the theatre, dinner or a night club. We would also shop for clothes and buy rations. We usually took the governess with us, so she could

care for Susan and Kenneth while we were out and about in the city. I must have been a dead-ringer for an Outback woman because one time at the races I kept swishing my gloved hand in what some call the Great Australian Salute, when a turf official approached, "You must be a bush lady... I can assure you madam, there are no flies here!"

Adelaide was also the best place to buy your fishing tackle. Fishing was popular with all the family. Amazingly, when Cooper Creek went dry the landscape was littered with lots of big water holes, which teemed with fish, mainly good sized yellow belly, callop and silver bream. Keen fishermen would turn up at Mungeranie and I would direct them to fish at one of the lakes near the Birdsville Track. They would eye me suspiciously for they could not believe that this desolate, dry, dusty and unforgiving place could have great fishing spots. Their isolation meant they were not over-fished. We used to say, "Bait your hook behind a bush otherwise a fish will grab it before you get to the water". After a good soaking in salt water, the fish made an excellent meal.

As the Cooper Creek began to run dry, there wasn't any permanent flow to the river and 'lakes' formed intermittently along the water course. These were giant water holes. As the water evaporated and levels dropped, fish began to die, often stuck in the mud. Birdlife increased one hundred fold and they feasted grandly on the glut of fish, which were easy to catch in the muddy shallow water.

On rare occasions, we also drove to Lake Eyre, normally a giant salt pan, but in times of flooding rain, filled by Coopers Creek. When that happened, pelicans came in their hundreds

of thousands. In this vast sea of plenty, the birds gorged themselves and bred prolifically. Eventually, the lake dried up and many of the birds did not seem to sense the great danger of remaining where they were and stayed until it was too late.

On one occasion, in 1963, we went to Lake Eyre to witness Donald Campbell's attempt to break the world land speed record in his car Bluebird on the dry salt pans. We found it very interesting watching the preparations. The salt had to be levelled and heavy machinery brought from down south had to do the work. Levels were very important for safety reasons. Just before Donald Campbell raced, his wife, Tonia, gave him a little teddy bear called Mr Whoppit, as a good luck mascot. On that occasion, even with his lucky charm, he did not succeed.

Eric and I always enjoyed June 25th, our wedding anniversary. Although we rarely went anywhere, it was wonderful to be able to spend this time together. Sometimes during the day, we would jump into the Toyota and go off to chop some wood. At night, we would eat the cake I had made especially for the occasion, sit by the fire, have a few drinks alone, or, if friends were about, we would play cards, usually Poker or a game called Joe, although people in Adelaide called it Mao. The official name is Mau Mau, but there are many variants. Playing cards was such a big thing in the bush. It kept our minds alert and enabled us to socialise with a lot of fun and laughter. Often, Eric and I would be joined by the governess, Miss Elly and Phillip Oldfield. When visitors turned up and we were obliged to entertain them in the sitting room, I would hear the staff having fun playing cards. I often wished I was

there with them, rather than being politically correct, chatting with a government official, or whoever came to visit.

Our family shared many happy, carefree days in the Outback. We quickly learnt that you had to have a keen sense of humour to survive living on the Track. When Susan was just a baby, Eric and I drove the 60 kilometres to a party at Mulka Station. On our return home, we must have travelled at least three-quarters of the way to Mungeranie when I said to Eric, "I think we are missing something… " To our astonishment, we had left the party without our precious daughter. When we arrived back at Mulka Station, Susan was still sleeping blissfully in her bassinette, in the spare room, exactly where we had left her.

At home, I busied myself with my poddy calves, making and selling jewellery and putting on morning and afternoon teas for tourists travelling through the area. As the years rolled on, the tourist numbers increased steadily. People would say to me, "Val, why are you putting all that work into raising those calves? Your husband has plenty of money. You don't need to be caring for poddy calves." My reply was always, "well those calves would be dead if I didn't care for them. They would be put down at the outset of the muster, so they would not slow down the mob heading for Marree. I like the idea of saving them and I enjoy what I am doing."

Frankly, I wanted to be an achiever. Often I would be up working late at night, making jewellery in time for the arrival of an aircraft from Lyndhurst next morning. All my jewellery was purchased and flown to various parts for re-sale at retail prices.

I got so busy I found I didn't have a lot of time to worry about Eric. In retrospect, that must have made him feel very insecure. He certainly resented it. Oldfield women were not supposed to become independent, yet I was 'driven'.

I immersed myself thoroughly in other diversions too. One was in the 'beauty industry' that came about by chance when a friend, who was a beautician, came to stay with us at Mungeranie. She was a representative for Vanda Beauty Counsellor, which sold beauty products. As a treat, she gave me a demonstration using her kit of products. The 'decadence' of the facial and cosmetics was amazing. The perfumes of the products were light, refreshing and feminine. I marvelled at the beautiful little bottles, the sweet lavender coloured decorative touches of the packaging and all the sweet trimmings. Oh, how I wished my friends of the Outback could have shared the time we had, exploring the kit of Vanda. To me, living in such a remote and harsh place, it was as if the luxury of Paris had arrived on the doorstep. It was a thrill and very therapeutic.

I wanted to 'share' the experience of beauty treatments with my family and female friends in the Outback and discussed this with my friend. She suggested I became a representative for Vanda Beauty Counsellor. I pondered it for just a few moments. The products were very reasonably priced and it could be a fun thing for me to do. Such feminine wiles were certainly missing from lives of women in the Outback.

I initially underwent a training course with Vanda Beauty Counsellor and started giving Outback women beauty treatments. Sometimes, these would be timed to team with hairdressing sessions, courtesy of a hairdresser who would fly

into stations such as Mungeranie on what was effectively, a flying hawker – a small aircraft that carried all sorts of goods and services on a station 'hop'.

I also worked in concert with a hairdresser at some of the stations and at Birdsville at one of the annual race meetings. There was a cacophony at Birdsville, with women chatting, gossiping, laughing and luxuriating in facials and pedicures while their hair was coiffed. The social contact and the touch and caring of women were no doubt just as important as the physical and emotional impact of the 'treatments' given. Whether it be in a small, intimate group of women, or the sometimes boisterous surrounds of the race day type preparations, the women would be transformed. They emerged happy, vibrant and confident, which was often in vivid contrast to their lacklustre, begotten demeanour upon arrival.

The racing time beauty work at Birdsville almost 'eclipsed' the races, with us taking over the hospital, courtesy of the understanding nursing staff. The hairdryers were going all-out, when the power to much of the town was cut. It seems our little enterprise was too much for the town's only power source, which came from an Artesian bore. Apparently, the most incensed were film goers at the Birdsville Hall. They quickly dispensed a messenger to the hospital, begging us to turn the hair dryers off. The power restriction however, did not clip our wings, we managed and ensured the women did not miss out. Their transformations were the most wonderful reward.

Not surprisingly, many of the men had no appreciation of the value of these beauty sessions and products. They did not even have an inkling of understanding. I laugh thinking about

the various remarks, especially those made by younger males, like the son of Eric's sister, Laurie, married to George Morton at Pandie Pandie Station. The lad was obviously mystified, saying, "Aunty Val, why have you got all that shit on your face?" I felt like saying, "It's not shit. This is normal for women who don't live in the Outback and women in the Outback need this too." I may have even said something like that, knowing that he would not 'get it' anyway.

My Vanda Beauty Counsellor escapades were one of the best things I have done in my life. It boosted my morale hugely to see the appreciation of women and being instrumental in their transformations. This also earned me some money although that was not the motivation for starting. However it did become important as my marriage deteriorated. I became one of the top sales consultants and won five barbecues for my trouble!

All those years ago, cousin, Joan Dunn, came over to Mungeranie from Kalamurnia Station and stated the obvious, "Oh Val it's not a living here, it's just existence." Joan knew all about doing it tough. During the long years of the drought, she and Jimmy were running a general store in Marree and then a butcher shop. Jimmy would kill a beast on the station and cart it to Marree to sell in the shop. In those days, you rarely knew where Jimmy was on his way home. He had the unfortunate habit of falling asleep at the wheel of his vehicle. He would be driving along, fall asleep and the car would keep going way out into the gibber country. When his son, Peter, was a toddler, Jimmy taught him to steer the car. So whenever dad fell asleep at the wheel, Peter would stand up on the front seat, one leg

on either side of his father's body and keep the vehicle on the straight and narrow. Driving along the Track in those days you rarely saw another vehicle. Just as well for Jimmy could well have had a head-on crash. However, when his car ventured off the graded track and into the gibber country a crash was unlikely.

While at Kalamurina, one of Joan and Jimmy's workmen met and fell in love with a governess who was working at Cowarie Station. He proposed, she accepted and they decided to celebrate their engagement at the Marree Hotel. His fiancée arrived long before him and when he got there, he began to celebrate the occasion with his mates downstairs. Meanwhile, the girl he hoped to spend the rest of his life with happened to be raking in the money, working as a prostitute in a room above the front bar. He was a delightful young bloke and when he learnt what was happening he was devastated. However, he moved on from the relationship and remained loyal to his employers at Kalamurnia.

Despite the hardship, Joan Dunn often said that she would never have wanted anything other than the life she had led on the vast shifting sand hill country of Kalamurnia Station, or the 10 years they spent at Carlton Hills Station in Queensland, where, Jimmy says, "there was no sand, just stone and heavy scrub." Since 1994, Joan and Jimmy Dunn have lived on 300 acres of prime country near Mount Pleasant, close to all facilities and far enough away from the hustle and bustle of the city.

In the 1960's, the Oldfields virtually 'owned' the Track. Claude Jnr and Eric were at Cowarie Station until Eric and I

married. Kevin Oldfield ran Clayton Station and Uncle Jim and Aunty Ida had the Etadunna Station. Claude and Jim Oldfield married sisters, Dora and Ida Scobie.

I admired Aunty Ida. Apart from being a real character, she was a very honest, straight forward person. She hailed from a famous family. Of course, Scobie was a famous name on the Track. Alexander Scobie began the family history in Australia, sailing from Scotland in 1879, with the hope of carving out a successful career as a pastoralist. His wife, Mary, and their four children joined him in 1883. Alexander was associated with Mulka Store, once an oasis for travellers who dared venture onto the Track. His three sons remained on the Track for years. Alec ran Ooroowilannie, Jim was at Mulka and Dave at New Well.

In 1924, the Scobies sold Mulka to George 'Poddy' Aiston, who after service with the Australian Army in the Boer War, was stationed at Mungeranie as a police officer. Alexander Scobie died at the age of 75, but his widow, Mary, was ever stoic and continued to live in the Outback, eventually taking up residence in Marree. But there was no house readily available for her when she arrived. "Then I shall live at the Coffee Palace!" Mary declared defiantly. As D-Day loomed on the shores of Occupied France, Mary Scobie died in the Marree Hospital. It was June 6, 1944. Being inextricably linked with the Scobies was some coup for the Oldfield family: the start of the Oldfield dynasty on the Track.

Through my marriage to Eric, I was very much an Oldfield, living with an Oldfield and surrounded by Oldfields and their relatives, of those who either thought they were a part of the dynasty, or wished they were a part of it. The Oldfield family

pretty much ruled the roost in that vast territory. I got the distinct feeling that to divorce an Oldfield was out of the question.

As a city girl, I missed the interaction with my friends and family. We had the galah sessions over the wireless each day, but the conversation could be boring. Rarely did we have stimulating discussion or debate. Yet, despite this lack of great conversation, the galah sessions were vital for us, in that we were interacting and talking with others who knew and understood the loneliness and the isolation of the Outback.

Loneliness, isolation, rats, mice, lizards, snakes, the never-ending dust, drought, floods, no social life, almost no stimulating conversation and a husband who was away so much were, when combined, too much to bear. When Eric was at home, he became increasingly moody – the conditions no doubt taking their toll on him too. There was either silence, sometimes for weeks, or arguments, and both became a part of our lives. They were also typical of the Outback experience. Regardless of my love for Eric, the situation wore me down physically and emotionally and for my own safety and sanity and my children's well being, I knew I had to leave Eric and say goodbye to Mungeranie.

Thankfully, raising my poddy calves, selling jewellery, organising morning and afternoon teas and my beautician work had helped me accumulate a tidy sum of money. The financial independence I had gained did not sit well with Eric.

Dad knew I was unhappy, but my parents were not keen for me to leave Eric. They saw the Oldfield family as a lift in 'station' for their daughter. However, Dad was also concerned for my future well-being and offered me land at Semaphore

Park where he was building a block of units. He said he would allow me to build a master unit within that complex – a holiday home. I organised to build a three bedroom unit and then had it furnished.

Unfortunately, I became increasingly discontented and unhappy at Mungeranie and worried intensely about sending the children hundreds of kilometres away to Adelaide for schooling. I cannot describe the emotional turmoil of determining the best thing to do. While my deep love for Eric had waned, the memories of it were strong. At the same time, the situation that had grown between us had become unbearable. I was sure it would impact upon the children, if it hadn't already. I was equally in turmoil about the children, wondering how they would cope if they were wrenched away from the environment they knew.

In exploring options for our marriage, Eric and I decided to try to reconcile our differences. We worked hard at the marriage and for a time, the situation improved for us both. We were relatively happy. Eric thought, and maybe subconsciously I was in agreement with him, that if we had another child there might be room for reconciliation, a new start to the marriage. I was keen to have another baby. Heaven knows how many miscarriages I endured.

I vividly remember driving to Mt Hogarth in 1968. Love was in the air. Since then, I have always said Martin, our third child, was a 'Mt Hogarth baby'. Eric said he spent so much money on 'baby things' at John Martin's department store in Adelaide that we should name the baby Martin, so Martin it was!

We travelled to Adelaide and I made an appointment with a general practitioner, Dr Hawke, who confirmed our baby was on the way. I needed regular medical attention and soon after travelled 380 kilometres from Mungeranie to Leigh Creek for a check up with a Dr Gregory. While I was in Leigh Creek, I walked into the town's only store and bought myself a dress. As there wasn't any fitting room, I threw the dress over the one I was wearing and hoped it would be a good fit. I don't know whether my new dress fitted me properly or not, all I know is, how liberating it was for me to be able to go and buy myself a new item of clothing.

Dr Gregory was not only a fine physician, but an avid collector of snakes. One learnt these sorts of things during appointments in the Outback! Once the men on the station took what was believed to be a Womma snake, a type of python, to Dr Gregory to identify. The men in a muster camp on our station had been keeping the snake in a hessian bag. They would do this simply to surprise newcomers sitting around the fire. The men would throw the reptile bits of food and generally play around with it. The reptile was very heavy and immensely strong. It took three men to get it back into the sack where it was kept. I was concerned, because it didn't have the usual python markings. When I drove with the children to the camp to deliver food, I took no chances. I kept the engine of the Toyota running, the doors locked and the windows shut. To get the snake positively identified, some of the men eventually drove to Leigh Creek to Dr Gregory. They returned with white faces, with Dr Gregory declaring the snake was poisonous and anything but a python and scalding them for their reckless handling of the creature.

Our third child, Martin, was born on December 6, 1968. After many miscarriages, he was very special to me. I was 32 and had lived in the Outback for what was, for all its ups and downs, largely been the best 10 years of my life. But for all the love which abounded at Mungeranie over the new baby, our relationship again began to disintegrate and hit a really sour note. I knew it was time for me to make a decision.

I weighed up pros and cons of living at and leaving Mungeranie. I guessed, if the children and I left, we would not miss the hot, dry weather and the flies, but we would never again enjoy such marvellous experiences as the breaking of a drought and rains bucketing down. I knew we would miss the drovers, ringers and stockmen, many characters of the Outback and, of course, our dear Rita, whose gentleness and sometimes curious ways rubbed off on us all, even somehow penetrating Eric's tough hide. At the same time, there were new and different experiences and relationships ahead of us if we left.

Overshadowing all of the innumerable pros and cons were two things. Firstly, the children's Father, who they were very attached to and formative memories were based at Mungeranie. They adored the place and had a carefree lifestyle they could never have hoped to experience in the city. There were also several people, like Rita, who they loved deeply there. Secondly and countering this, the two people they loved most were at odds with each other and worryingly miserable. My conclusion to leave came down to this: it simply was not healthy for any of us for the marriage to continue.

Susan was nearing the age of ten and Kenneth was eight when I finally decided to leave Mungeranie. Ironically,

I was visiting Adelaide with the children when I came to the realisation. Mum and Dad suggested that I go to Kangaroo Island to sort myself out while they looked after the children. On my return to Adelaide, I knew what I had to do. There was no dramatic farewell from the station, no fleeing the homestead in tears and temper, with crying children tugging at my emotions. I had been through the emotional mill long before this. I simply knew, that it was time for me to say farewell to Mungeranie.

NO BEATING ABOUT THE BUSH

Mungeranie bore-drain (River Derwent)

Life after the Outback 15

Leaving Mungeranie Station was a huge wrench and a shock for all of us. I knew the children were just as distraught at leaving the station as they were with their parents breaking up. They went through emotional trauma, tearful moments, misery and despair that I guess all children whose parents separate go through. The fact that so many others experience the same does not lessen its significance.

Although my children had some knowledge of the area around the three-bedroom unit at Semaphore Park, which was ideal, they set about exploring their new environment. They loved the freedom at Semaphore, especially the beach. Susan and Kenneth soon attended Ethelton Primary School. Despite the radical change for them and their difficulties adjusting, schooling kept them occupied.

I could not have anticipated some of the adjustments the children had to make. Learning to handle money was typical of these. Having lived in isolation, without shops in cooee, they had no understanding of money. I was shocked and amused the first couple of times I let them go to the shops to buy ice cream. I had given them a coin each for their purchases and they

returned with change, most excited that the shop had not only given them the ice creams, but had given them money too. The next time they were given more coins in their change and they were sure they had actually made money on the purchases. It was obvious that I had to teach them about money.

I had to learn a great deal too. Prior to my marriage I had never been responsible for shopping for a household. While I had shopped for supplies in Adelaide after my marriage, I simply did not know where to shop for some things that I would have picked up in places like Marree, or where the best places were in Adelaide to buy certain things. Also, I was used to buying supplies for a station property and so bought foodstuffs in large amounts. It took me a long time to adjust to buying smaller amounts for my family in the city. I do not think that I have ever adjusted to that properly. I still tend to buy more than is needed.

Eric stayed at wie for a year or so after we separated. He then sold the property and moved to Adelaide where he bought a unit at Tranmere Village, before moving to Plympton and later buying a small farm at Meadows, in the Adelaide Hills. Much later, he returned to the Outback and ran Eric Oldfield Outback Cattle Drives. Kenneth recalls his father's sense of self at about the time he moved to Adelaide saying, "Dad was a bit like me. He was lost. In Adelaide, I was like a fish out of water. I yearned to get back to the Outback." I took the children to see their Father on a regular basis, although sometimes Eric picked them up from home. It was a time of great stress and emotional turmoil for us all.

I must admit that my new life in Adelaide was marvellous.

LIFE AFTER THE OUTBACK

The dust storms, sand, flies, loneliness, hardships and boredom were gone. I had a telephone, a television, my friends and family and I learnt to play golf. I also had the sheer joy of going to the shop to buy fresh bread. At Mungeranie, if someone brought out week-old bread covered in mould two centimetres deep, everyone thought it was wonderful once the mould had been cut off. In the city, I had an endless supply of wonderful fresh bread.

To help provide for us, I continued selling jewellery and working as an area manager for Vanda Beauty Counsellor. Looking after three children, keeping the household running, shopping and cleaning kept me extremely busy. I felt I was leading a busy, productive and meaningful life.

I occasionally went out with a friend, Don, who I had met a few years before. He was very caring and kind and helped me through some very difficult times. We got on famously, dancing, partying and enjoying life. Our friendship lasted many years. Eventually, we both spoke of marriage but I wanted the children to have a home without a male taking the place of their father – a place they would be proud of and where they felt they belonged. I had become independent and confident by this time and in addition to my thoughts about the children, marriage simply did not hold any appeal. I didn't see myself as a married woman again. I liked the freedom of being a single mum.

After a few years, I rented out my unit at Semaphore Park and took a lease on a place in Plympton, where the children started at Woodlands Grammar School and Westminster College. After two years there, they moved in with their father,

which I naturally found hard to bear, but could understand. Then I bought a run-down house in Parkholme, which took six weeks to renovate, because it was unliveable.

A defining moment for me however came not long after I had moved to Semaphore Park, when I had accepted an invitation from my next door neighbour, Joylene Smith, to attend a yoga class at St John's Centre, Semaphore. I had practised some of the movements, called asanas, at Mungeranie after reading a book on natural childbirth. It outlined the advantages of yoga for expectant mothers. I had thoroughly enjoyed it. It was tremendous exercise for the body and mind. It was the first class that I attended with Joylene that had me really hooked.

By the time I had really got into the swing of yoga classes, Martin had begun his years of education at Forbes Primary School and Susan, aged 15 and Kenneth, aged 13, had gone to live with their father in Plympton. I was attending weekly yoga classes at Edwardstown Oval Hall and my teacher, Iris Clutterham, gave me great encouragement. She urged me to study hard and help her with the tuition of some school children. I jumped at the opportunity and worked as her assistant throughout 1972.

A year later, I began demonstrating yoga under the expert eye of Indian born Swami Saravasati, who had a yoga television program and demonstrated at Tea Tree Plaza Shopping Centre. Swami Saravasati had married an Australian surfer and lived in Sydney, but she promoted and led interstate yoga demonstration tours. She didn't smoke or drink and was always good for a laugh. "Laughing is like internal jogging," she would

say. After my experience in demonstrating yoga with her, Swami recommended me for a full teacher's membership to the Australian and International Yoga Association. Meanwhile, my role with Iris Clutterham increased and I was taking two classes for her every week.

In 1974, I started teaching yoga at Legacy House for war widows and ran a class at Netley Primary School under the umbrella of the SA Further Education Department and classes at Plympton Park Scout Hall and Masonic Village. While at Masonic Village, I was asked to do something for the very elderly. In developing the classes, I struck upon the idea of letting the students sit in chairs and do yoga, rather than on mats on the floor. This made it less daunting and possible for many who would not have been able to do it otherwise. The seniors were delighted with the movement and the new concept in the use of yoga philosophy. It was a huge hit and was picked up by newspapers nationally. I was then given a contract by South Australia's Education Department to run six-week classes in schools to introduce students to yoga. Adelaide Girls, Mitchell Park and Vermont High Schools were among them. I did similar classes at private schools like Walford Church of England Girls Grammar School and Presbyterian Girls School.

The classes grew to such an extent that I formed the Shanti School of Yoga which was a training school for other teachers. I found the need to employ yoga teachers. With specialised training, we were able to go out and teach yoga to people in nursing homes and the disabled. I established classes at numerous Southern Cross Homes and other nursing and hostel homes.

All the yoga groups loved it. I remember a lady who had lost confidence in moving about because she had lost flexibility and strength in a leg. She patted her knee and said, "Listen here darling, this knee has been pushing up daisies for 15 years". So I said, "Let's look at the parts of the body you can move". After many sessions, she bent and moved that leg. She was not the only one with tears in her eyes. It was the start of a new beginning for that woman. Another lady, who had been in a wheelchair for 15 years, progressed to the point where she could walk. She had lost confidence in herself but regained both skill and confidence through the class.

I guess I immersed myself into the role of teacher. I also embraced the Yoga prayer:

> God gives us the ability to love, rather than to be loved
> To understand, rather than to be understood
> To give, rather than receive
> And to forgive, rather than to be forgiven
> For it is in loving that we are loved, and it is in giving that we receive.
>
> Shanti

In 1977, I became a member of the International Yoga Teacher's Association, a body recognised internationally as the top teaching accreditation organisation. It took me six months as an associate member, passing examinations in philosophy and physical yoga, before I gained full membership. In 1985, I became a Master with the Australian and International Yoga Teachers' Association and in September, 1990 I became a full member of the SA Institute of Yoga Teachers.

I was appointed yoga teacher on board P&O Cruise ships and lectured from 1978 to 1997, working as an instructor on a number of internationally-known ships including the TSS Fair Princess; TSS Fairstar; Proud Australia, Achille Lauro Star Lauro cruise; Oriana and Arcadia. On the night of March 30, 1980, the ship hosted "Ladies Night", a gala affair that included a sumptuous dinner and fabulous entertainment. My souvenir menu was signed, along with an appropriate note, from one of the entertainers on board the S.S. ORIANA, "Val, if a picture paints a thousand words, I'm glad I'm with DULUX – Rolf Harris."

For four years, I also ran a travel business called Happy Time Tours from my Parkholme home. During that time, I hosted many small and large tour groups – two with more than 100 passengers – and travelled all over the world. Many were on the S.S. ORIANA.

I was also very honoured when I was nominated for the Premier's Award one year. The assistant principal of the Shanti School of Yoga, Dawn Wallace said, "Her great contribution began in 1974, when Val was asked to start a yoga class to help the elderly residents and the disabled at the new hostel section of the Masonic Village in Somerton Park. Due to a number of factors, including the age and fitness of the residents, Val decided to convert normal yoga practice to a style which could accommodate her elderly 'students'. She conducted sessions with the participants seated in chairs…" I did not win the award but considered I was already victorious in influencing the way the elderly embraced yoga and the physical accomplishments of some of them. One was Lloyd Quick of North Plympton who

had suffered a list of physical setbacks as a result of a stroke. After attending our classes, he was able to lift his arms and use his legs.

I ran yoga classes for the Over 50's at Henley Community Centre which proved a huge success. Unfortunately, I found myself embroiled in a fight, aired by Messenger Newspapers, with Charles Sturt Council which decided to withdraw funding from my program. Fortunately, the council ultimately decided to continue funding the program.

My other business and working ventures were many and varied. In 1984, I founded the 'Touch of Class' club which provided opportunities for people over the age of 25 to mix socially by attending barbecues and picnics, and taking trips within SA and abroad. Membership grew to more than 400.

From 1985-1989, I was the proprietor and manager of Peaches and Cream Beauty Salon in Gawler Place, Adelaide. I was a busy woman, but I also managed to attend a number of courses such as the 'Train the Trainer' accreditation yoga course, a travel manager's qualification, a public speaking course and the Alpha Personal Management seminar. I was all about improving myself physically and emotionally and finding pathways to create new business opportunities. I had created a secure and comfortable lifestyle for myself and my children.

In the 1990's, I helped a number of leading sports people with their focus and concentration. Champion table tennis player Ann Middleton was one. Ann later became recognised internationally for her creative design of jewellery. The other was a young man named Chris Lilly, who had won two Under-18

national 8-ball titles and was runner up in another. When he moved into senior ranks, he began to lose concentration during matches. I had a number of meaningful sessions with Chris. His father, Peter, who managed the Sturt River Caravan Park wrote me a recommendation.

It was dated January 30, 1996 and said in part, "After Val's instruction, Chris has been able to focus his mind on the game and the results have followed. In 1995 he represented Australia in the 8-ball team playing in Las Vegas, in the US. The team came 17th out of 260 from around the world. He is also the current national 8-ball doubles champion. Although Val is not instructing Chris at the moment she still finds time to ring him to see how his game is progressing."

In 1998, I also became a full operational member of the SA Sea Rescue Squadron.

In 1989, I had married Aldo Iglio. We enjoyed our time together, but the relationship did not last. I guess I was in love with being in love, because I fell in and out of love many times.

In 2002, the year of Eric Oldfield's last Outback cattle drive, I met and married Denis Arbon. Denis worked for the SA Housing Trust. He was a solid man with a good sense of humour. Denis and I got on very well and together we have enjoyed life immensely. We have a lot in common including our interest in horse racing and we were and continue to be members of the South Australian Jockey Club.

My son, Kenneth is still the likeable young man with a mischievous glint in his eye. He has been through the wars with a variety of accidents and mishaps, including a major calamity when a huge branch fell on his head while he was cutting a dead

gum tree down with a chain saw. He had been in a paddock near Kapunda when a branch broke off and fell from high up in the tree. He recalls being bloody and disorientated. Initially, he couldn't find his way out of the paddock, but followed his tyre tracks. He had the good sense to close the gate because there were shorn sheep wandering about and he headed down the road. However, the blow to his head was starting to take effect. He was in a daze. He stopped in the middle of the road. Luckily, a car stopped alongside him and helped. Unbelievably, it was Nugget Coppin from Kapunda, he was with a mate. Nugget's son had been in a plane which had crashed some years before, killing Eric's nephew, Grant Oldfield. It seems Nugget's destiny was strangely intertwined with the Oldfield's. A year prior to this Eric's cousin Kevin Oldfield (Junior), was also killed in a plane crash. Kevin had bought Mungeranie from Eric.

Another of Kenneth's mishaps included breaking his leg when riding his motor bike and overshooting a sand hill. He also had a nasty accident when working to help clear the wooden sleepers off the old Ghan railway track. He and others were knocking out the pins of the sleepers and working with chains to lift the sleepers when one of the chains broke, whipping his legs and injuring him.

Martin, who left Mungeranie when he was just 18 months of age, grew up knowing little about our time at the Birdsville Track. He inherited his grandmother's love and talent for playing piano. He has had a varied and fascinating working life, helping me with the yoga school and then working in hospitality. One of his achievements was being appointed as a Duty Manager at the Renaissance Hotel in Sydney. I was

extremely happy for him. He took great pride in his work and accomplishments. He later went into real estate valuation and property management. He is happy living with his partner, Peter and they have been together for 11 years.

Susie too, was happy and in love until a day in May, 2009 when tragedy struck.

NO BEATING ABOUT THE BUSH

Bore drain (River Derwent), Birdsville Track with Mungeranie in the distance.

My Darling Suzie

15

My world came crashing down the moment I heard Martin's faltering voice:

"Susan's dead, Mum."

"What?" I said disbelievingly, my hand holding the mobile phone in a vice-like grip. "Don't talk such rot, Martin. I don't believe you." Martin persisted, distressed and incredulous.

I told Martin I needed to talk to the police. I just could not believe what he was saying. My beautiful girl, dead? No way.

Somehow, poor Martin had arrived at the crash scene. He had been travelling south along Port Wakefield Road and had stopped at the crash site to discover the mangled, burnt wreck before his eyes belonged to his sister, my daughter, our beloved Susan. It must have been ghastly for him. I shudder at the thought of Susan's death and at the cruel twist of fate that Martin came upon the scene.

Denis and I were driving in Adelaide to a friend's place when I received Martin's shocking call on my mobile phone. We switched plans and headed to the police. They confirmed that my darling Suzie was killed in a road accident. She had

been driving from her home at Kadina to Adelaide in her Toyota Camry station wagon when her car ran off the road, crashed into a large gum tree and burst into flames.

I was emotionally numb – in shock I guess. I simply could not "take it in," let alone accept it. We went home and I was still in a daze when a policeman who had attended the crash site kindly visited us in the evening. I was very concerned for him, having to attend not only the crash site of my daughter's car, but many others. I wondered how he coped with it all and was asking him questions about that. I think that is an indication of my own shock and denial at the time but I still wonder how police cope with it all.

There were television reports about the crash. They seemed no less surreal than a report about the accident that appeared in the Wednesday, May 13, 2009 edition of The Advertiser (see right).

We learnt that there was a young couple in a car just behind Suzie. They realised something was terribly wrong when her car swerved off the road. She corrected the vehicle and it returned to the road before heading off it again. The young man in the vehicle behind dialled 000 on his mobile phone and was ready to send it before Susan even struck the tree. The post mortem revealed that Suzie had suffered a heart attack. We didn't know that Suzie had a heart condition.

The couple had a young baby aboard and so had kept their vehicle well back from Suzie's car which was almost immediately engulfed in flames. They feared the car would explode. The young man stopped his car, jumped out and raced to the vehicle. He tried to prize open Suzie's driver front door, presumably with a

> **Driver's death marks tragic week**
>
> Michael Milnes
> Police Reporter
>
> A Kadina woman became the sixth person in a week to die on the state's roads when her car hit a tree and exploded into flames yesterday. The woman, 47, lost control of her Toyota Camry station wagon and slammed into a large tree at about 11.45am, 2km south of Lower Light on the Port Wakefield Road, about 40km north of Adelaide.
>
> Several motorists, including a truck driver, tried unsuccessfully to get her out of the car and put out the flames. An Adelaide Now reader said one of his company truck drivers was one of the first at the scene.
>
> "It got worse (and he was) unable to put it out. He is still in shock himself," the article said.
>
> Three Country Fire Service appliances and a rescue unit were at the scene within minutes and extinguished the fire, but it was too late to save the woman, who was the only occupant of the car. The state road toll stands at 46 – 15 more than at the same time last year.
>
> *(The Advertiser, May 13, 2009)*

tyre leaver, but the door was wedged hard against the tree. All his brave efforts were in vain. The intense heat from the fire drove him back. As it did, trucks stopped. I understand something like 25 fire extinguishers were used on the car but the flames could not be extinguished. It seems that the fuel line to the petrol tank was spewing petrol and feeding the fire.

Later, I visited the young couple who stopped to help my daughter. The young man risked his own life trying to save Suzie.

My main concern was that Suzie might have still been alive in the burning car. I had nightmares about the horror of it all. However, according to the Coroner's report, Susan was killed the instant her car slammed into the tree. I can only hope that the Coroner was right, but in reality no-one really knows.

The reality and shock of it all overcame me the day after the accident when I went to Gawler, where Suzie's body had been transported to. Of course, I could not see her but I was allowed some solitude in a small courtyard next to the room where she had been taken. It was a very private time and I was overcome with grief. All that had been, all that was, had come down to a dizzying melee of distress. At moments my thoughts were filled with 'what ifs' and self reproaches, over little things. Most of all, the thought that my beautiful, vibrant daughter would never walk through my door again, wrenched at my soul. Those who have lost a child will appreciate that there can never be the right words to express the dampening of spirit that happens then. Sadly, as much as one honours their loved one's life and gets on with things to live a happy, fulfilling existence, that dampening never leaves you.

When I look back, I cannot help but have regrets. On Mother's Day, a couple of weeks before Suzie's death, she was in fine form. Her man, John, obviously adored her and she him. We had a wonderful day and she suggested we have a "girlies" day lunch and then go shopping in several days. I had already arranged to meet some friends for lunch on the date she suggested. I had cancelled with them once already and didn't want to do it again. Suzie happily set a new date and I suggested she catch a bus to Adelaide on the journey so she could work on her laptop. On that fateful day, Suzie decided to drive to the city.

About 400 people, from all walks of life, attended the funeral at Centennial Park. They loved Susan because she was a people-loving girl, whose personality touched us all. She had

a wickedly funny glint in her eye and a good heart. I wrote the eulogy, but I needed someone to read it for me at the funeral. Martin's friend, Peter Aldritt, agreed to do it.

SUZIE'S EULOGY
My darling daughter Susan

You were born in a hurry on August 9, 1961 at Queen Elizabeth Hospital. The doctor who brought you into the world said the birth was amazing and a contradiction to all medical books. You were a beautiful baby with a mop of dark hair. At first sight, you were loved and adored by all. Your father and I took you home to Mungeranie Station on the Birdsville Track. You were a perfect baby and always good, provided your food was on time and you had loads of attention. At 9½ months of age, crawling was just too slow – things to see and do, so you were off walking. So began the getting into mischief.

Your love of animals began at an early age, but bull ants were classed as food. Poor Gran Burnard sent you a basket of sweets for Easter and there you were, this pretty, little two-year-old girl dressed in pink with the basket on the veranda, not worrying about the sweets, but using it as a bait for bull ants which you picked up and devoured, sometimes with the legs hanging out the side of your mouth. One little stamp with your bell slipper sent them into a frenzy – no worry to you, a bite or two from them didn't matter – you fixed them up by eating more.

You had no fear of heights – a 60-foot free light tower, you and Kenny scaled and to show how brave you were...

waved to me, both hanging on by only one hand. I was afraid of heights but somehow I climbed up and brought you down, one by one.

Horse riding was one of your loves. Even at a few years of age, you loved sitting on Ah Foo and as your dad went about his work, the horse followed him and you just sat there sometimes for an hour or so. When you were older, you and Kenny rode "like the wind" and the few times I accompanied you, I was terrified that my horse would put his leg in a rabbit burrow. All I got was "come on mum, you're too slow." Later, we were so proud to see you ride in the Salisbury Hunt Club children's event. The only problem was you went so fast over the jumps that you passed the hunt mistress. But you really showed the city children how a bush girl could ride!

What a schemer you were! Poor Kenny – he was constantly led into mischief. After he drank kerosene his father decided to wire up the pump on the kerosene drum. You took Kenny to the pump and said, "If you suck really hard you'll get some". Of course, next thing we were off again in the Flying Doctor plane.

Your love of animals shone through all your life. Baby budgerigars which had fallen out of their nests were brought home for me to hand-rear – hot porridge they loved and thrived on. Baby rabbits and our little white dog "Snowy" had to have their broken legs mended with plaster from the Flying Doctor medical chest. Kittens and dogs were especially on your list to look after and love. You came home one day with a pink galah who became "Pedro" and he ended up the boss of all the animals – a bite on the nose put all the cats and dogs in their place.

When I fed the poddy calves you were there and often they would suck your fingers and hand. Later your pets were Rottweilers and Ridgeback dogs – Cleo, the Ridgeback had a litter of puppies and you told me how you saved two of them. Your dogs were your constant companions; they were your shadow.

Your education on the Station was by way of correspondence lessons, with the help of a governess and School of the Air. When you were nine years old I decided to take you to Adelaide to be educated, rather than send you to boarding school. For three years you attended Ethelton Primary School and you excelled as a scholar. You then went on to Woodlands Girls Grammar School and again proved your academic qualities.

We had wonderful times together, birthdays spent at the Pizza Palace on Anzac Highway, and happy holidays at Kangaroo Island with old Myrtle at Linnettes, feeding you up on all her wonderful meals.

At the age of 15 you went to live with your father, who by this time had shifted to Adelaide. You attended Vermont High School, before becoming a pharmacy assistant in Glenelg and then to John Martin's, where you worked as a consultant for Helena Rubinstein. And so began your love for beauty therapy – you studied and became a beautician at Burnside Village and later owned Suzetts Beauty Services. A cruel blow struck when at the age of 20 you were diagnosed with Type One diabetes. This did not deter you; you dealt with it in a very positive way. It always amazed me how you took everything in your stride and managed to work and enjoy life. I know at

times it was extremely difficult for you but it was always a smile and "let's get on with it."

You met Peter and went to live at Port Hedland. Here you helped him with his trucking business and later you were married. For several years you were happy, but unfortunately the union didn't last and you parted company. You began working in real estate at Walker & Keipert and to your credit you attended TAFE College and received a certificate from the Douglas Mawson Institute of Business Practice. You became office manager at Walker & Keipert and then began your university studies for A Bachelor of Business. How proud I was the day you received your degree, with your brother, Martin, who also graduated.

So there I was with two children accomplishing so much. You then went on to become a property conveyancer and conducted a successful home-based business. Conveyancing was your specialty and so your clientele grew. Numerous people came in and out of your life, but in recent times John was the one who made you sparkle and shine. On our last Mother's Day together I remarked how well you looked and you told me how happy you were. I teased you and John about getting married, only later to find there were some serious thoughts in this direction. On Mother's Day we made plans to celebrate my next birthday at a resort on Kangaroo Island where you and John had recently stayed. You were so excited about the prospect of once again seeing all the bush animals which were so tame they came right up to the front door of your unit.

The baby koala you could not stop talking about – how beautiful it was – how soft and cuddly it felt as you nursed

it in your arms. The fishing was great so a date was set for us all to go in November. What a great day we had, thank you for those memories and the memories of all our happy times together as a family; the times we spent lunching and shopping. Thank you for being my beautiful, unique daughter. Thank you for your love and support. Thank you for being you.

You will always be in my heart.
I love you,
Mum.

There was so much emotion, there was hardly a dry eye at the service. Busloads of people came from Kadina to the funeral to convey their love and pay their respects. Debbie Pisani, a dear friend of our family from the time Suzie was a toddler, couldn't make her funeral, but she did send me a letter from England. It read, in part:

"Anyone who was fortunate enough to know her would agree, you could not find a more kind, warm-hearted, generous soul and funny – no-one was funnier and no-one loved life more than Suz."

Because Suzie was an animal lover, instead of giving memorial flowers, we asked mourners to consider donating, in Suzie's memory, to the Animal Welfare League. Suzie was a very caring and kind-hearted daughter, good in so many ways.

If I have regrets about my children, it is that I didn't see enough of Susan and Kenneth after they went to live with Eric. It was difficult as they were very much drawn into the Oldfield clan at that time.

Suzie's passing was such a traumatic event in my life; I doubt I have ever fully recovered from it. Her 50th birthday was a terrible day. However, life goes on. Establishing a charity in Susan's memory was a solution to help me move on. She loved animals and children. I thought how good it would be to have a charity in Susan's name, helping deaf, blind and ill children who so desperately need our love and support. This would enable me to keep Suzie's memory alive by helping others in her name.

With the help of an enthusiastic committee – everyone donating time and effort – I now run fashion events, morning and afternoon teas and cocktail parties. These are all held under the banner of the Suzie Oldfield Memorial Children's Fund. It works collaboratively with Can Do 4 Kids and other registered charities. As there are minimal administrative charges, every cent raised goes to supporting the children. Our reward is seeing the faces of children 'light up' when they receive a Braille computer or a Vox Speech machine or receive some other form of help. One delightful child I met at a special ceremony at Government House was five-year-old Anthony, who had just become the recipient of a Braille computer – a device which will help Anthony's educational pathway in life that little bit easier. What a thrill it was for me to meet this delightful young man who was helped by Suzie's fund.

My contacts in racing circles and experience in interacting with people from all walks of life certainly help with my charity work. I have now started speaking at Rotary Clubs, the Flying Doctor Service auxiliary branches and a number of other worthy organisations. They ask me to speak to them about life

on the Track. People are fascinated by those who have lived 'the life' and have survived to tell the story. They often sidle up to me and say, "Hey, Val, you've got such a great tale to tell, why don't you write your life story?" And I think to myself, *'What a good idea'*.

THE END

NO BEATING ABOUT THE BUSH